IMAGES
of America

BRICK
TOWNSHIP

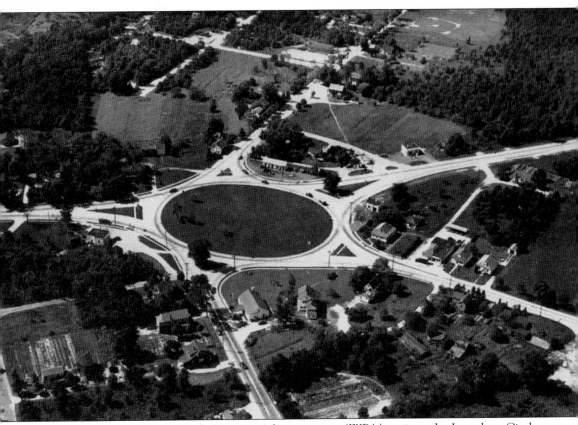

Constructed in 1937 as a Works Progress Administration (WPA) project, the Laurelton Circle replaced "dead man's curve" at the intersection of the road to Lakewood (Route 88 West), Point Pleasant Road (Route 88 East), and Toms River (Route 70 West).

IMAGES
of America

BRICK
TOWNSHIP

Eugene E. Donatiello
and John G. Leavey

ARCADIA
PUBLISHING

Published by Arcadia Publishing
Charleston SC, Chicago IL, Portsmouth NH, San Francisco CA

Printed in the United States of America

Library of Congress Catalog Card Number: 2008927173

For all general information contact Arcadia Publishing at:
Telephone 843-853-2070
Fax 843-853-0044
E-mail sales@arcadiapublishing.com
For customer service and orders:
Toll-Free 1-888-313-2665

Visit us on the Internet at www.arcadiapublishing.com

CONTENTS

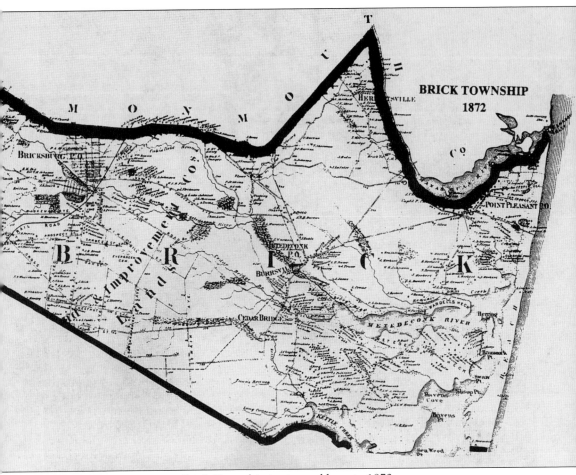

Brick Township is pictured here in 1872.

Acknowledgments

Authors and collectors spend long, hard hours collecting, researching, and recording information on their areas of interest. Along the way there are other individuals who have contributed to the author's knowledge by sharing their experiences, stories, and artifacts.

While the majority of images that follow are from the collections of John Leavey, Gene Donatiello, and the Brick Township Historical Society, there are many individual contributors of photographs and information without whom this book could not have been completed.

We, the authors, wish to thank Lenora Donatiello and Rosemarie Leavey for their assistance in editing and the following individuals and institutions for sharing with us their knowledge and photographs: Brick Township Historical Society, Inc., Bonnie Chankalian, Dover-Brick First Aid, Mr. and Mrs. Walter Durrua, Jim Estelle, Carolyn Goble Hankins, Mr. and Mrs. Elmer Havens, Herbertsville Fire Company No. 1, Kevin Hughes, Ocean County Cultural and Heritage Commission, Mr. and Mrs. Barry Osborn, Bob Randolph, John Rotundo, Township of Brick, Margaret Vanderburg, and Jane Watkins.

INTRODUCTION

In 1850, when the New Jersey Legislature created Ocean County from parts of Monmouth and Burlington Counties, they also created Brick Township. The new Township was named after its most prominent citizen, Joseph W. Brick, the industrious and successful owner of Bergen Iron Works.

At that time, Brick Township included all the land from the eastern boundary of Jackson Township to the Atlantic Ocean. The area included the villages of Adamston, Bricksburg (Lakewood), Bay Head, Burrsville (Laurelton), Cedarbridge, Herbertsville, Osbornville, Point Pleasant, West Point Pleasant, Mantoloking, and a portion of Normandy Beach.

By 1920, six of the villages had declared their independence. The beach area, once known as Squan Beach, developed into farms and fishing and resort areas. Point Pleasant Beach and Bay Head were the first to break away in 1886 and were followed by Mantoloking in 1911. Lakewood, which had been the center of population developed by the Bricksburg Land and Improvement Company, broke away in 1892. The village of West Point Pleasant became Point Pleasant Borough in 1920.

Though these villages became independent they did play a role in Brick's history. They had centers where Bricktonians could shop and where they could sell the products from their farms and industries. The railroads came to these villages and carried products to distant markets. The railroads also brought visitors and potential buyers to the resort communities that were developing in Brick in the 1920s and 1930s.

The early settlers to this area were involved in a variety of industries, including iron, charcoal, turpentine, and fishing. Most of the people were farmers who grew corn potatoes, tomatoes, and other vegetables for their own use and, then, as cash crops. They all had barnyard animals; everyone had a cow for milk, a pig, and chickens. Most inhabitants had a second occupation; some built houses, others built boats, some were fishermen, some were merchants, others operated taverns and inns in their homes, and just about everyone hunted.

The area, with its well-drained sandy soil, was a natural for raising poultry. Poultry as an industry began when the Park and Tilford Company, a major producer of poultry and eggs, opened Laurelton Farms on the Road to Lakewood (Route 88 West). Jewish immigrants arriving in the 1930s continued the industry into the 1950s.

The Atlantic Ocean, Barnegat Bay, the Metedeconk and Manasquan Rivers, and their tributaries have played a major role in the Township's development. The Lenape, the first people to live here, settled along the rivers where there was an abundant food supply. With the arrival of the

first white man, came the lumber, pinewood, and iron industries that used the rivers and bay to transport their goods to city markets. Farmers would graze their cows in the meadows along the bay and rivers. In addition, the waterways were used for fishing and boating. The cranberry industry thrived in the watery bottom lands. In the early 1900s, summer camps were popular along the waterways, and they were followed by the construction of resort developments. Brick Township continued to be a quiet, rural, resort area into the 1950s when the Garden State Parkway opened. Residential and commercial development then began to dominate the scene, creating a dramatic growth in year-round population.

As is true about any community, Brick Township is people. From the Lenape to the present inhabitants, each has built upon what the previous generation had accomplished. They have developed a community from the virgin woodlands, to a rural resort, to a thriving suburban community.

One

PEOPLE

As new people arrived in the Brick area they brought their customs and religion with them. Following the Lenape, who had been longtime inhabitants, the first white settlers were Quakers, Baptist, and Methodists. They built their churches, which became the center for village activities. Parents wanted their children educated, so schoolhouses were built. Each village had a school, usually a one-room, ungraded school, which later housed grades one through eight. Through religion and education, standards were being set for the generations that followed.

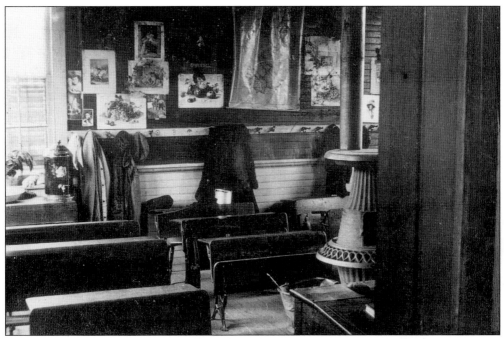

Cedarbridge School, c. 1890.

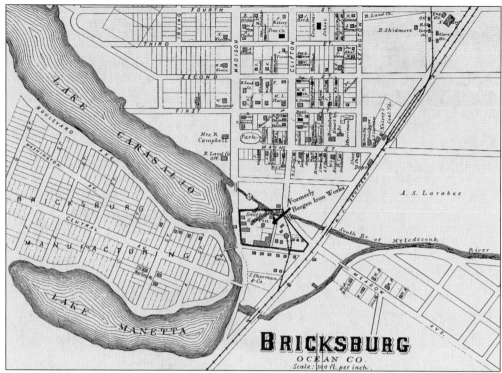

BRICKSBURG
OCEAN CO.
Scale: 500 ft. per inch.

Joseph W. Brick's Bergen Iron Works was located on the South Branch of the Metedeconk River (at Route 9). The river was dammed to create two lakes, which supplied water power for the works. The larger of the two lakes, Lake Carasaljo, was named for Joseph Brick's three daughters, Carolyn, Sarah ("Sally"), and Josephine.

Carolyn Virginia Brick (1835–1866) was the daughter of Joseph W. and Margaret Allen Brick. In 1856, Caroline married Charles R. Woodworth.

Sarah Augusta Brick (1842–1897) was the daughter
of Joseph W. and Margaret Allen Brick. In 1861,
Sarah married Joseph R. Partridge.

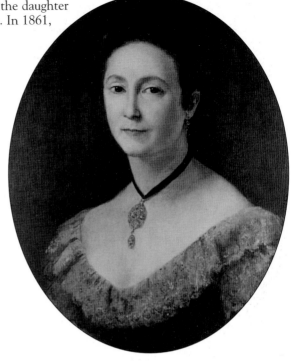

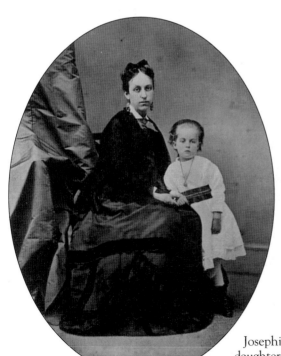

Josephine Emma Brick (1844–1875) was the
daughter of Joseph W. and Margaret Allen Brick. In
1863, Josephine married Charles A. Stetson.

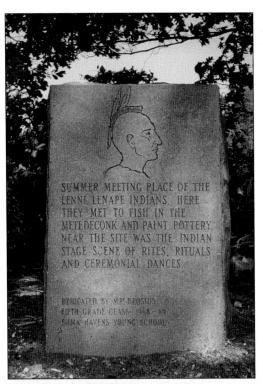

Native American artifacts dating back to the Paleo-Indian Era have been found scattered throughout Brick Township. Indian Stage, a ceremonial ground, is located on a rise overlooking Forge Pond on State Highway 70 West.

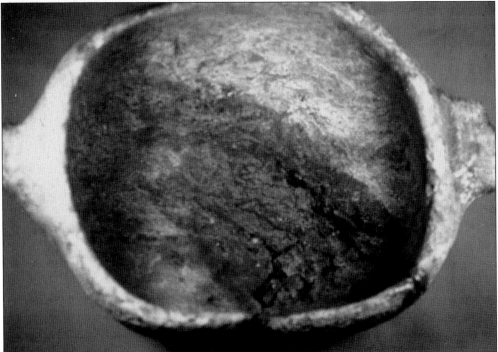

There has always been evidence of the Lenape living in the Brick Township area. Pictured above is a beautifully preserved steatite bowl in perfect condition. Called the Herbertsville Bowl, it was uncovered at an archaeological site in Herbertsville in the 1940s.

Born May 24, 1804 in Pittstown, New Jersey, William B. Hill moved to the village of Point Pleasant in 1829 when he married Deborah Lawrence. Hill served in several government offices in Monmouth County. When Ocean County was created in 1850, Hill and Benjamin Snyder, a former agent at Bergen Iron Works, were elected the first freeholders from Brick Township. In 1852, Hill was elected superintendent of Brick schools.

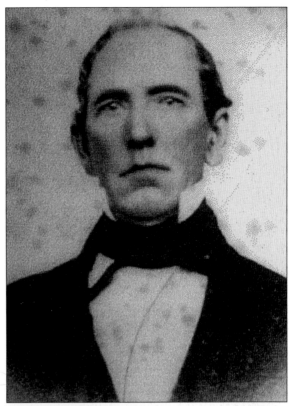

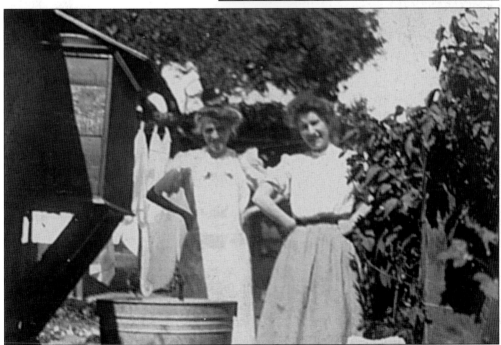

There was no washer or ringer for these two Herbertsville women. Charlotte Havens and her mother used a wash tub and clothesline on wash day in this 1890s photo.

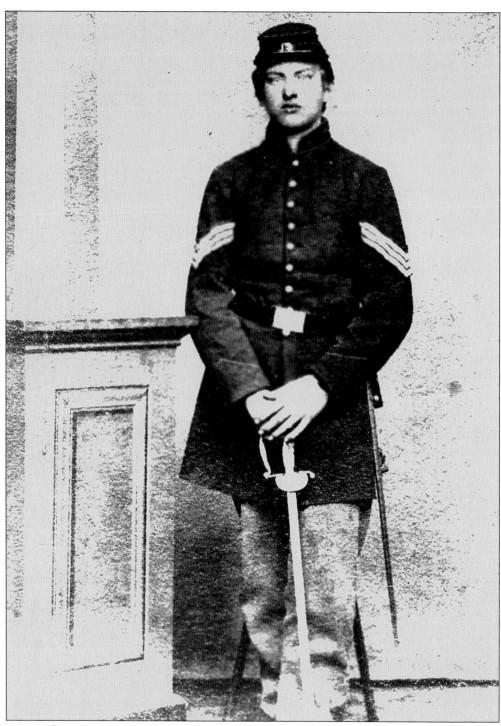

Among the many citizens of Brick Township to serve in the Civil War was Henry "Harry" Clay Havens of Burrsville. Havens was a first sergeant of Company F, 14th New Jersey Volunteers. Henry volunteered on August 15, 1862 and was a seasoned veteran by age 20 when he was killed in action at the Battle of Monocacy, Maryland on July 9, 1864.

This is Isaac Tilton's certificate of exemption from the Civil War military draft. Tilton was able to provide a substitute to replace him for military service.

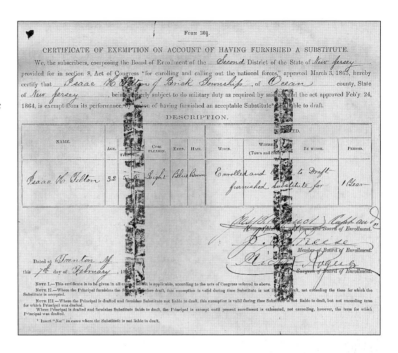

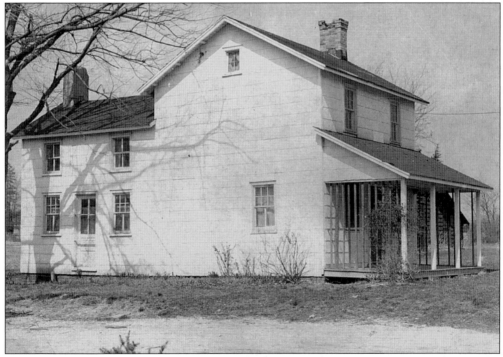

This pre-Civil War home, which once stood on Cedar Lane now Schoolhouse Road, belonged to Richard Pettit. In 1862, Pettit left his young family and went off to fight in the Civil War. Almost four years later, he was released from the Army at Freehold. Pettit walked home, sleeping alongside the road at night. Upon arriving at Cedar Lane, his children ran into the house to tell their mother a strange man was coming down the road.

Ocean County.

TOWNSHIPS.	NATIVE.				FOREIGN.				CHILDREN BETWEEN 5 AND 16 YEARS OF AGE.				Blind, Deaf and Dumb, Idiots or Insane.	Total No. of Inhabitants in Township.
	White Males.	White Females.	Colored Males.	Colored Females.	White Males.	White Females.	Colored Males.	Colored Females.	White Males.	White Females.	Colored Males.	Colored Females.		
Berkeley	357	355	1	2	1	107	113	71
Brick	1502	1351	4	6	58	45	429	370	1	8	296
Dover	1107	1054	59	62	364	344	1	228
Eagleswood	290	232	1	1	84	54	2	52
Jackson	775	708	1	10	9	253	217	150
Lacey	380	337	3	7	6	116	110	73
Manchester	426	420	2	3	65	61	139	184	1	97
Plumsted	763	698	26	24	32	25	230	198	3	7	4	156
Stafford	533	480	4	2	16	10	142	128	1	1	104
Union	661	727	6	2	147	182	139
Total	6794	6362	37	38	225	221	2011	1900	5	8	16	13,70

This is an abstract of the census for Ocean County, 1875.

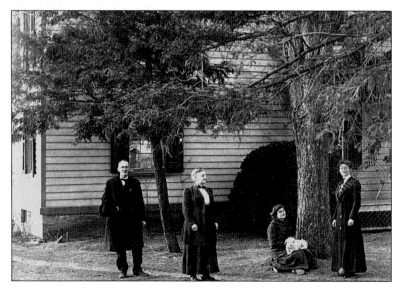

The Havens family of Laurelton pose in front of their home on the southwest corner of Route 70 and Route 88 West.

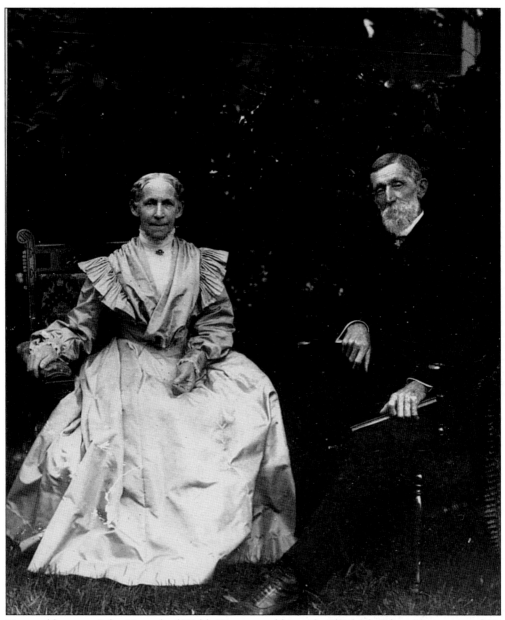

Pictured here are John Greenleaf Webb Havens and his wife, Elizabeth Tilton Havens, on their 50th wedding anniversary on December 28, 1904. John was a state senator from Ocean County from 1872 to 1875. John was also the director of the Fourth Life Saving District, running from Sandy Hook to Cape May.

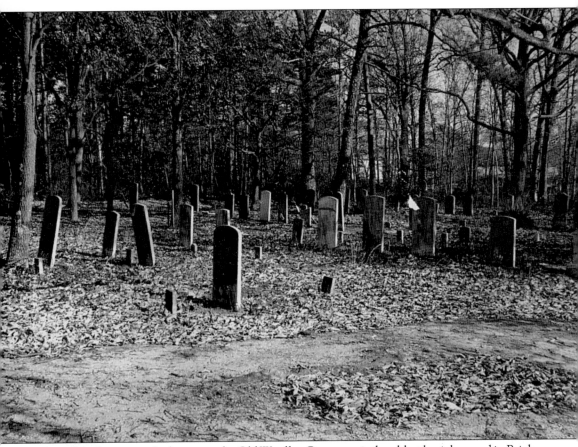

Gravelley Cemetery, also known as the Old Woolley Cemetery, is the oldest burial ground in Brick Township. Located on a rise above the Metedeconk River, it contains fewer than 100 graves. Among those buried there are Enoch Jones, who served in the American Revolutionary War; Isaac Elmer, a veteran of the War of 1812; William Johnson, a member of the first township committee; and Peter Leighton, a casualty of the Civil War.

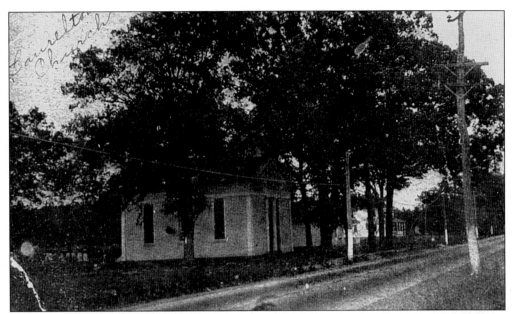

The Orient Baptist Church, or the First Baptist Church of Laurelton as it is presently known, was moved to Burrsville in 1843. The present building on Route 88 East, the oldest church structure in Brick Township today, was constructed by James L. Dorsett in 1857 and is listed on the State and National Register of Historic Places.

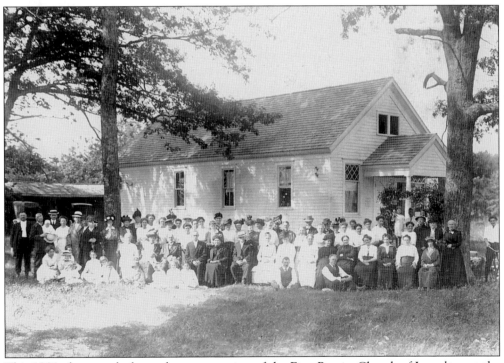

This 1901 photograph shows the congregation of the First Baptist Church of Laurelton at the dedication of Ivy Hall, located on Route 88 East.

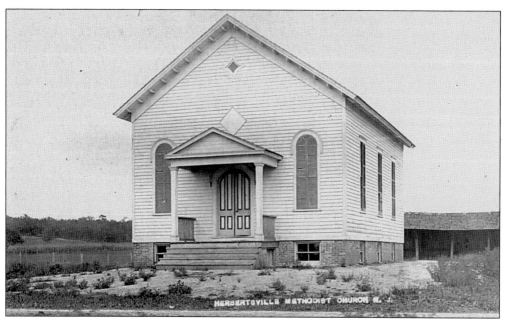

The Old Herbertsville Methodist Church was dedicated on January 30, 1876 and served as a community center until the congregation outgrew the building and moved up the road where they opened St. Paul's Church. In 1966, the Sons of Norway took over the building, using it as a meeting place and renting it to various groups. In 1998, the church was purchased by Epiphany Roman Catholic Church to be used as a parish hall.

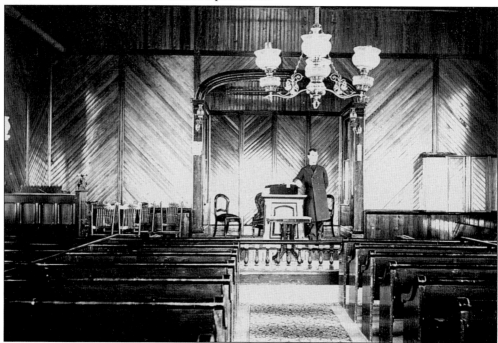

I.S. Whitaker was the pastor of the Herbertsville Methodist Episcopal Church in the early 1900s. The kerosene-fueled chandelier and wall lamps lit the church until the late 1920s when electricity came to the area.

Established in 1855 as the Methodist Protestant Church, the Osbornville Protestant Church, along with its cemetery, is located on Mantoloking Road.

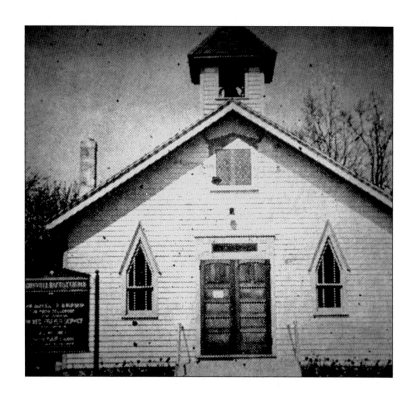

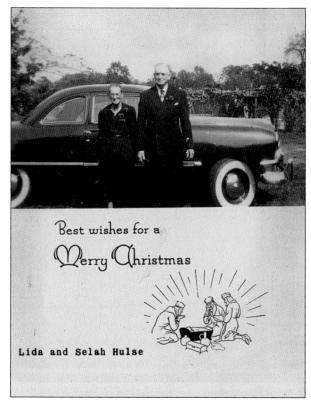

Best wishes for a
Merry Christmas

Lida and Selah Hulse

Standing in front of the 1950 Ford Coupe, the Hulses send season's greetings.

The Osbornville Baptist Church was organized in 1835 as the Kettle Creek Baptist Church. The first church building was erected on Baywood Boulevard. In 1901, the church was moved to Drum Point Road. The Kettle Creek Cemetery still occupies the land adjacent to the church's original location.

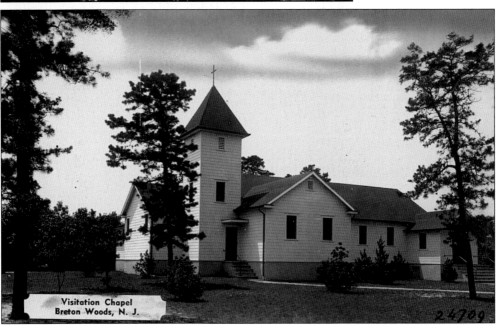

Visitation Chapel
Breton Woods, N. J.

24709

Churches have always been the community center for villages in Brick Township. As the resort industry brought new residents, these residents brought new religions. Visitation Roman Catholic Chapel opened in 1938 as a summer chapel to accommodate the new residents.

Born and raised in Laurelton, Emma Havens Young (1870–1968), the daughter of Horatio and Mary Lydia Havens, began her teaching career at the age of 17. Young taught in the two-room Cedar Bridge School and was teacher principal at the three-room Osbornville School. An elementary school on Drum Point Road is named in her honor.

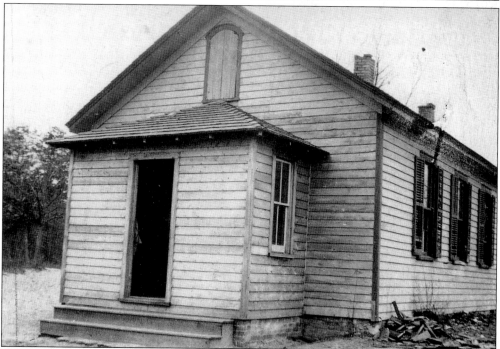

The one-room Cedar Bridge School was built in 1864 and became a two-room school in 1900. The school was located on the east side of Hooper Avenue just north of Drum Point Road. It was closed in 1914, along with the Osbornville School, and was replaced by the three-room Union School.

[Form No. A22—20M—4-1-13]

TEACHER'S CONTRACT.

It is agreed between the Board of Education of *Brick Township*
in the county of *Ocean* and *Selena Worth*
that said Board of Education has employed and does hereby engage and employ the said
Selena Worth to teach in the *Cedar Bridge*
public school, under the control of said Board of Education, for the term of *one* year,
from the *14th* day of *Sept.*, 1914, at the salary
of $ *360.00* to be paid in *nine* equal monthly installments;

_____ that the said
Selena Worth shall begin teaching on the *14th*
day of *Sept.*, 1914; that the said *Selena Worth*
holds a valid *Third* grade *County* certificate to teach, issued in New Jersey,
now in full force and effect, or will procure such certificate before the date he shall begin teaching, and
that the date when said certificate will expire is the _____ day of _____
19____, and that said teacher, before entering upon the duties of such position, will exhibit *her* cer-
tificate to the *County* Superintendent of Schools of the *County* in which such school is situate.

It is hereby agreed that either of said parties to this contract may, at any time, terminate said con-
tract and the employment aforesaid, by giving to the other party *thirty days*
notice in writing of its election to so terminate the same. [Here insert length of time.]

The said *Selena Worth* hereby accepts the employment
aforesaid and undertakes that he will faithfully do and perform *her* duty under the
employment aforesaid, and will observe and enforce the rules prescribed for the government of the
school by the Board of Education and the Superintendent, or Principal, or Supervising Principal.

Dated this *tenth* day of *August*, 1914

George E. Steinsko
President,

Board of Education of the
School District of

Brick Township

In 1914, when Selma Worth signed her teacher's contract she was to be paid $360 for a nine-month school year. A male teacher on the same contract was paid $400.

In 1922, Mr. Steinmuller, a teacher at the Herbertsville School, stopped to have his picture taken. In the background are Herbertsville Road and Sidney Herberts Store.

West Point Pleasant School

The first Ocean Road School in the Point Pleasant section of Brick Township was built in 1901 to house grades one through eight. The Ocean Road School replaced the Pine Grove Academy, which had been destroyed by fire a year earlier.

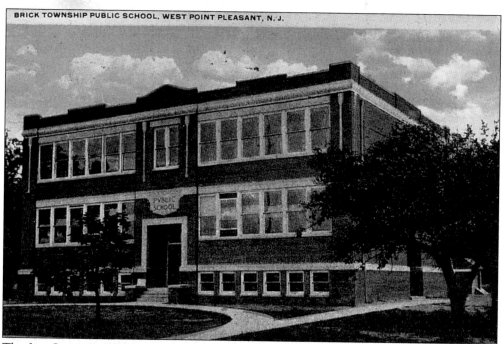

BRICK TOWNSHIP PUBLIC SCHOOL, WEST POINT PLEASANT, N. J.

The first Ocean Road School was destroyed by fire in 1915 and was replaced by the one shown above that served Brick Township and Point Pleasant until it was replaced in 1990.

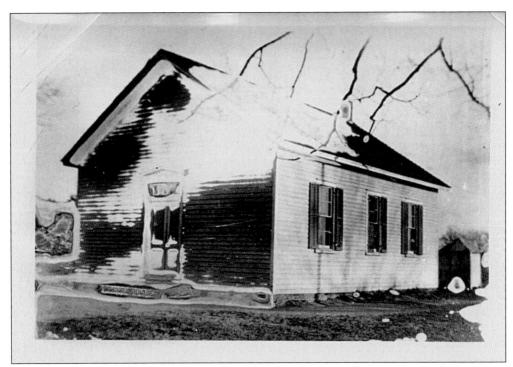

The Burrsville, or Laurelton, School served the community for at least 84 years. The one-room school had been established before the Township was formed in 1850 and was closed when the new three-room Laurelton School opened in 1934.

This three-room Laurelton School on Route 88 East replaced the original Burrsville School in 1934. An addition was made to the building in 1954.

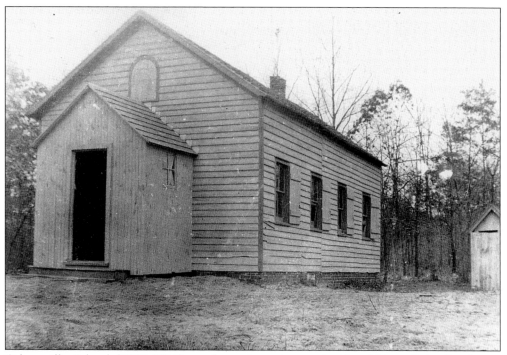

Osbornville School (1870–1914) was located on the north side of Drum Point Road near Adamston Road; the school was originally called Osborn's School. The three-room Union School replaced the Osbornville and Cedarbridge Schools in 1915. In 1938, the Union School was destroyed by fire.

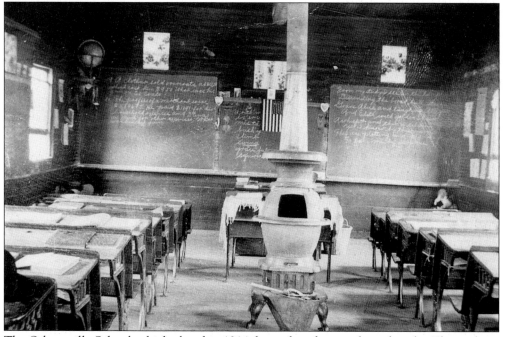

The Osbornville School, which closed in 1914, housed grades one through eight. The students were warmed by a pot-bellied stove in the center of the building.

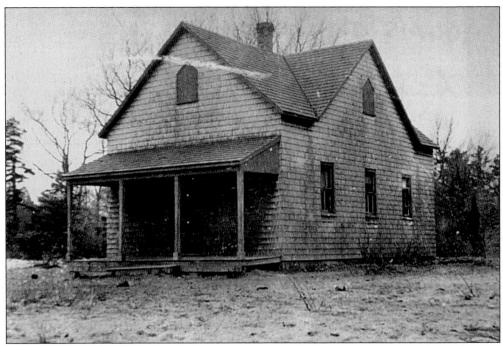

With its origins going back to the Metedeconk School, the West Mantoloking School began to appear on county records about 1900. Referred to by locals as the Adamston School, it was located on Mantoloking Road in the Sandy Point area and served the community until 1939.

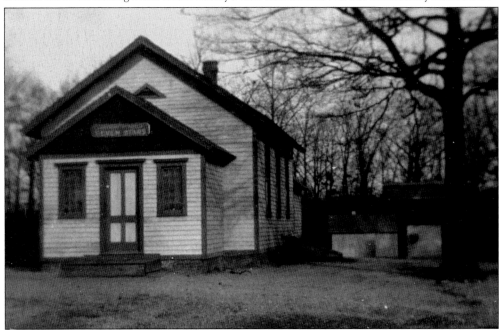

Originally a private school in 1872, the Seven Star School first appeared as a Brick Township school in 1878. Located on Chestnut Street in the southern section of the village of Lakewood, the school served the community until 1915. In 1996, the schoolhouse was moved to Cross Street waiting to be restored.

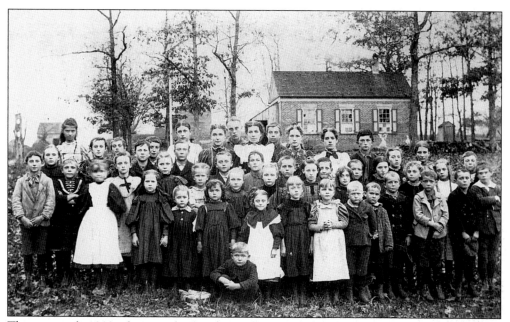

This is an early 1900s photograph of students who attended the two-room Herbertsville School. The schoolhouse appears in the background with the privy on the right and Herbertsville Road on the left. The 'x' marks Howard Havens, who later owned a dairy farm on Herbertsville Road, and his sister Laura.

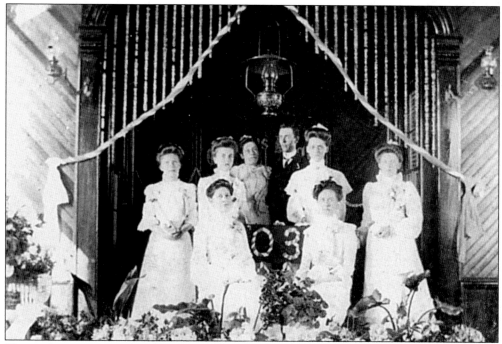

The graduation ceremony of Herbertsville School took place at the Herbertsville Church on Sunday, May 23, 1903. Members of the class are, from left to right, Ann M. Fisher, Edith Gifford, Abbie Herbert, Florence Gifford, Irene Tilton, Clarence Gifford, and Christina Osborn.

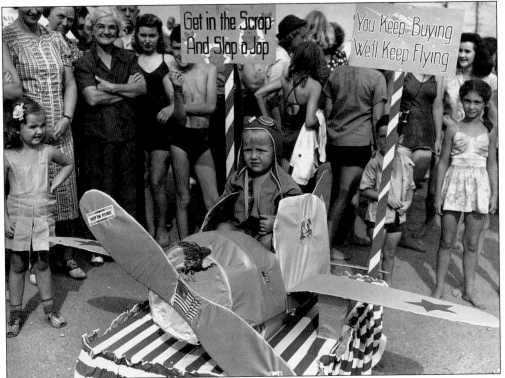

During World War II, everyone did their part to support the war effort. Here a young man from Breton Woods is promoting a scrap drive.

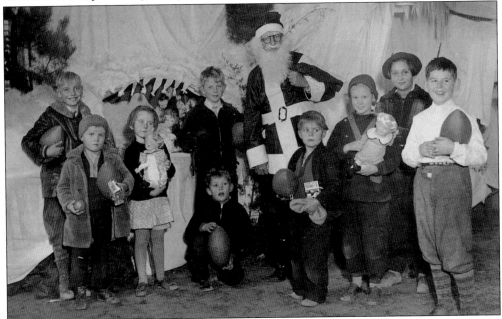

This pre-1934 photograph of Laurelton School students celebrating with Santa are, from left to right, Carl Spicker, ? Grischbowsky, Carolyn Goble, ? Grischbowsky, unidentified, Mrs. White as Santa, ? Grischbowsky, Jane Schenck, Julia Morris, and Franklin Goble.

Two

COMMUNITY

The sand roads linking the local villages of the 1800s were only wide enough for one wagon to pass at a time. Heavy rains caused the wagons to get bogged down, which lead Joseph Brick to build a log road later called Cedar Bridge Road. Before bridges were built, small streams had to be forded; ferryboats were used to transport people and goods across the wider rivers. Neighbor helped neighbor in times of need and eventually volunteer emergency services were organized. Later, government unified the people into an organized community.

Mantoloking Road, c. 1930.

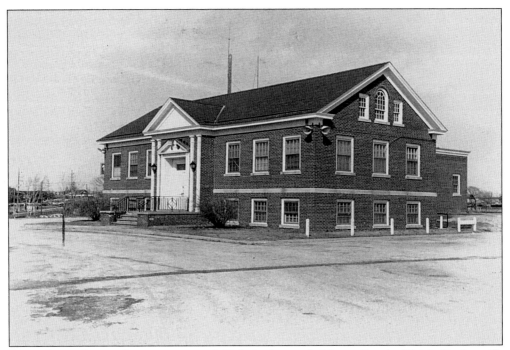

Located on the northeast corners of Cedarbridge and Moore Roads (Brick Boulevard), Brick Township Town Hall (1953–1977) not only housed Brick's municipal government, but also the New Jersey State Police, who patrolled the town until a local police department was created in 1972.

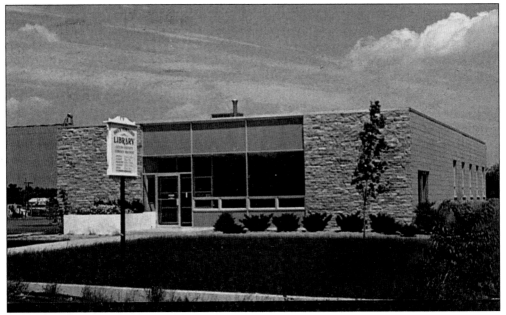

Brick residents were served by the Ocean County Library system since 1925. During the 1930s and until the 1950s, books were kept at stations in private homes in the Township. In the 1950s, the Friends of the Brick Library, led by Irene Alznauer, established the first library building, pictured above on Cedar Bridge Road. This library served the community until 1976.

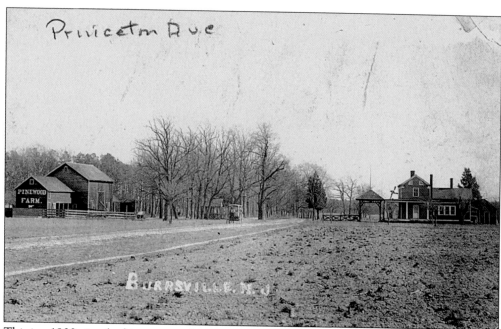

This is a 1900 view looking east on Princeton Avenue. Pinewood Farm, on the left, would be in the vicinity of the intersection of Post Road. Johnson's farm was to the right.

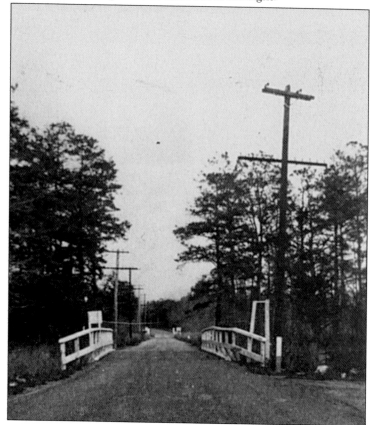

It was not until 1937 that the twin wooden bridges over the Metedeconk River at Forge Pond were replaced by cement bridges built as a WPA project. The road, called the John D. Rockefeller Memorial Highway, was designated Route 40 and, later, Route 70.

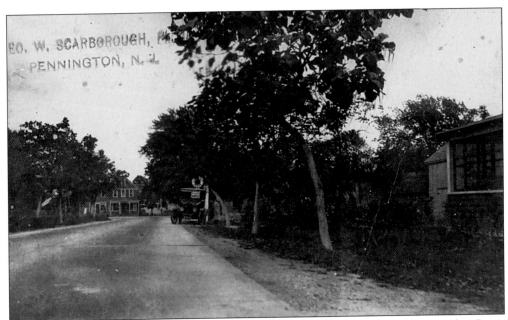

The first gravel road, built in 1904 by Ocean County Freeholders, ran from Lakewood to Point Pleasant. Here, where the road passes through Laurelton, it was made of concrete and known as Ocean Avenue, though later called Route 4 and, then, Route 88.

This photo is looking south on Herbertsville Road in 1900. On the left is the Herbertsville Church and on the right is the parsonage for the church.

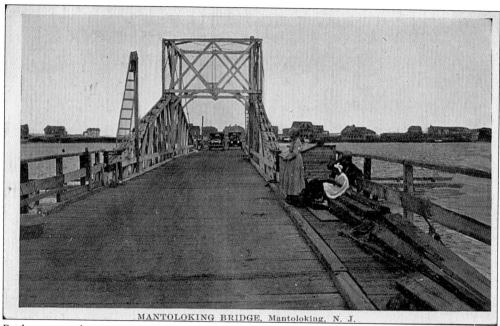

Bridges were always necessary for travel around Brick. This bridge crosses Barnegat Bay and links Brick Township with its beach area, later to become the Borough of Mantoloking.

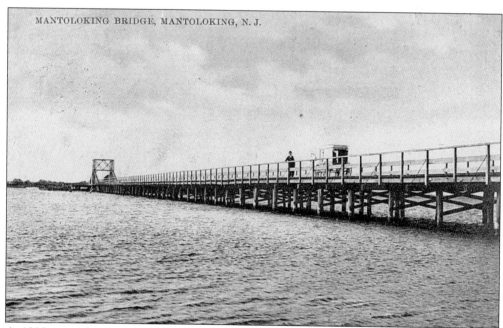

A 1909 water-level view of the first hand-cranked Mantoloking Bridge shows it crossing Barnegat Bay from Brick to the beach area.

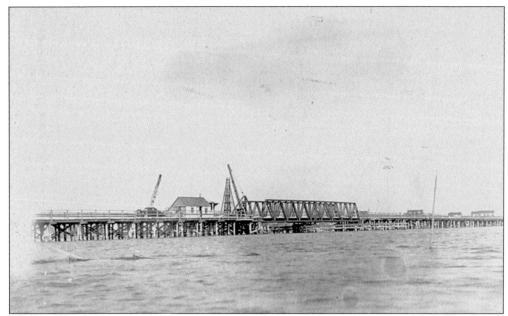

The second Mantoloking Bridge was a gasoline-powered, common swing-type bridge. This bridge was replaced by the present draw-type bridge, which was built as a WPA project in the 1930s.

The Old Wagon Bridge, or Osborn's Bridge, shown in this 1918 photograph spanned the Manasquan River just west of the present Route 70 bridge connecting Brick and Brielle. The present bridge was built in the 1930s as a WPA project.

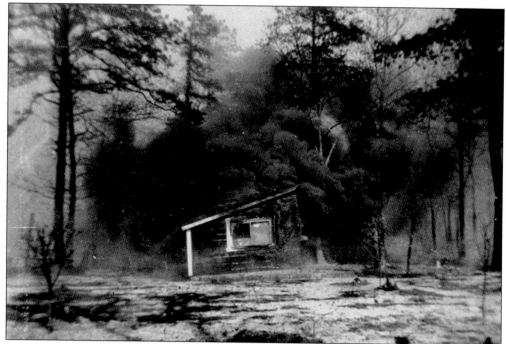

On April 14 and 15, 1926 a fire burned for 72 hours and affected an area of 30,000 acres in the Silverton and Adamston sections. Rusling Hulse, Gus Hulse, Arthur Falkinburg, Anton Hulse, Thomas Hulse, Joseph Wardell, and Henry Downey lost their homes. Also lost were several chicken houses, barns, and outbuildings.

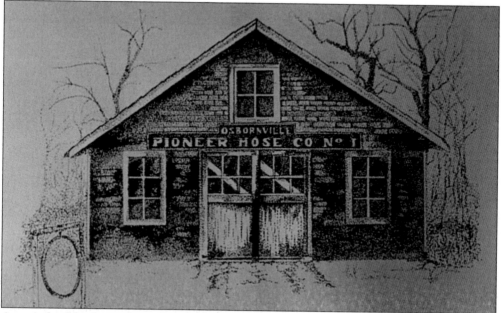

As a result of the devastating spring forest fire in 1926, the Patriotic Order of Sons of America set about organizing a volunteer fire department. By the summer of 1927, Pioneer Hose Company No. 1 was organized. Equipped with a 1927 Chevrolet fire truck, Pioneer was the only fire company in Brick Township until 1930 when the Laurelton Fire Company was established.

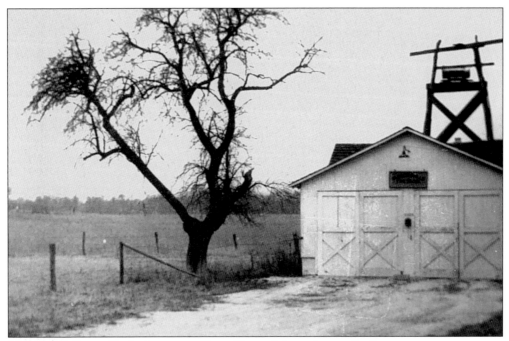

The first Herbertsville firehouse was Harry Havens's barn, but as the fire company grew, a new firehouse was needed. Mrs. Floyd Osborn gave the company her garage to use as a firehouse. The original alarm was a steel steam engine tire that was struck with a sledge hammer to alert members of an emergency.

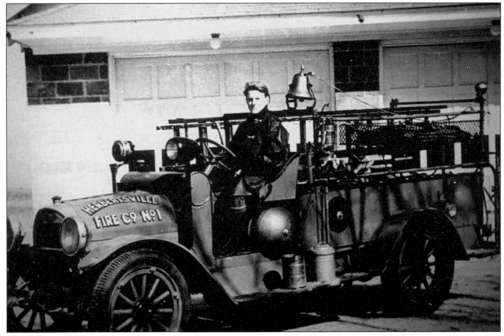

After several serious fires, a group of local men in the northern section of Brick organized the Herbertsville Fire Company in 1936. By October of that year, they had purchased their first fire truck, a 1927 REO, for $150.

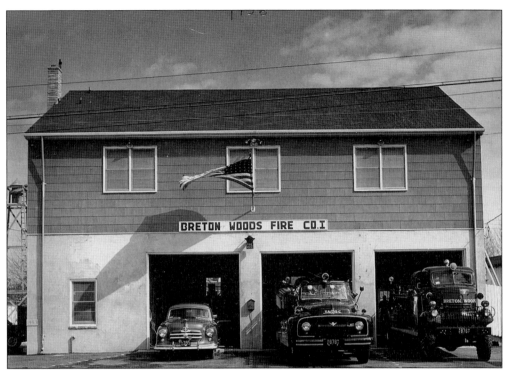

In the early 1950s, Breton Woods Fire Company No. 1 had a new Ford fire truck, a Rambler fire car, and a former U.S. Navy crash truck that cost $2,450. The company's firehouse on Mantoloking Road was built in 1953 at a cost of $30,000.

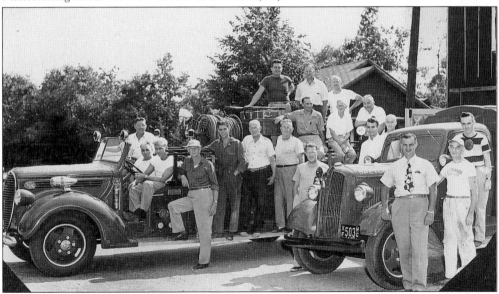

Breton Woods Fire Company was formed in 1935 by a group of summer residents in conjunction with the Van Ness Corporation. The Van Ness Corporation was the developer of several resorts along the south side of the Metedeconk River in the 1930s. With the help of the corporation, the fire company was able to procure a 1929 Hudson fire truck. This photograph was taken in 1947.

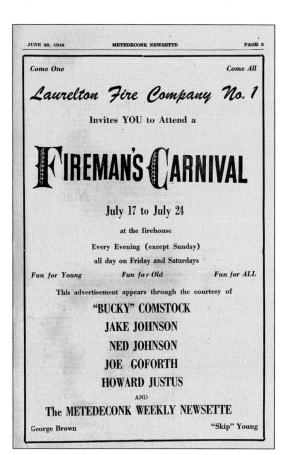

Come One Come All

Laurelton Fire Company No. 1

Invites YOU to Attend a

FIREMAN'S CARNIVAL

July 17 to July 24

at the firehouse

Every Evening (except Sunday)

all day on Friday and Saturdays

Fun for Young Fun for Old Fun for ALL

This advertisement appears through the courtesy of

"BUCKY" COMSTOCK

JAKE JOHNSON

NED JOHNSON

JOE GOFORTH

HOWARD JUSTUS

AND

The METEDECONK WEEKLY NEWSETTE

George Brown "Skip" Young

Here is the Metedeconk Newsette advertisement for the Laurelton Fire Company's fundraising carnival.

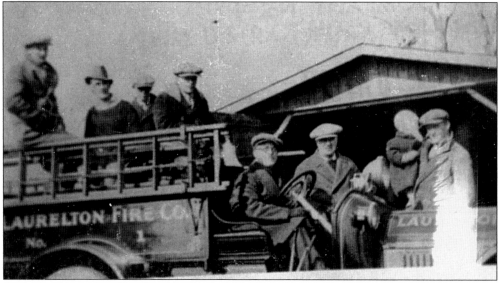

A serious forest fire that threatened several homes in Laurelton demonstrated the need for a fire company. On May 14, 1930, the Laurelton Fire Company was organized to safeguard the community. Members of the fire company are pictured here on their 1923 Cole Chemical Truck purchased from the Mt. Holly Fire Company for $450.

40

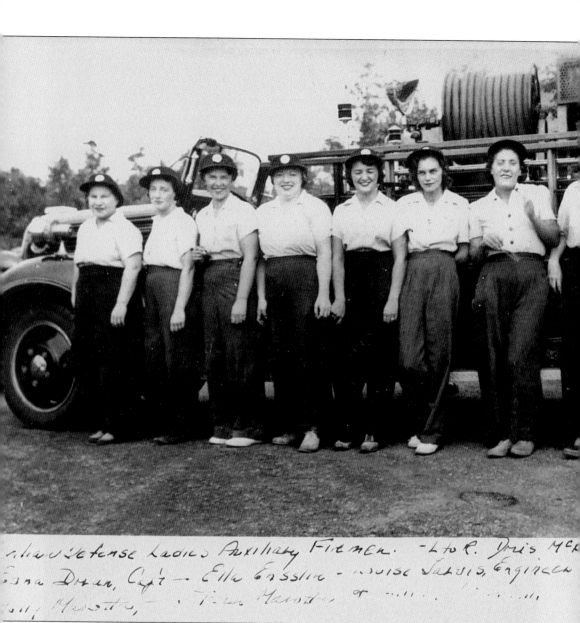

During World War II, not only did women turn out to work in factories, but on the farms as well. The ladies Auxiliary Firemen took over emergency services also. Pictured, from left to right, are Doris McKinley, Clara Pollack, Captain Edna Doran, Ella Ensslin, Engineer Louise Jarvis, Althea Christensen, Molly Marotta, and Lillian Wensell.

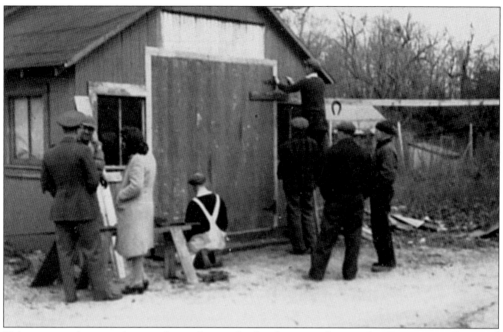

Volunteer workers can be seen here placing the finishing touches on the Community First Aid Squad's headquarters in the Adamston section.

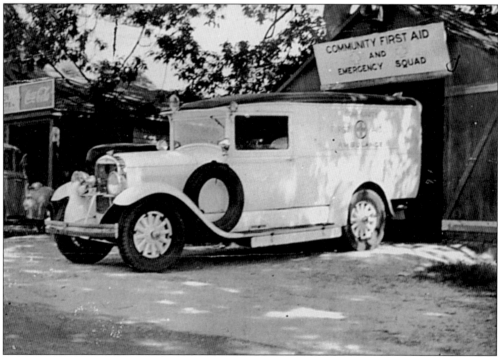

With the increase in the number of summer residents, there was a need for another First Aid Squad. In 1943, a group of volunteers from the Adamston section formed the Community First Aid Squad. Seen here is the squad's first ambulance, a Studebaker once belonging to the Lavallette First Aid Squad.

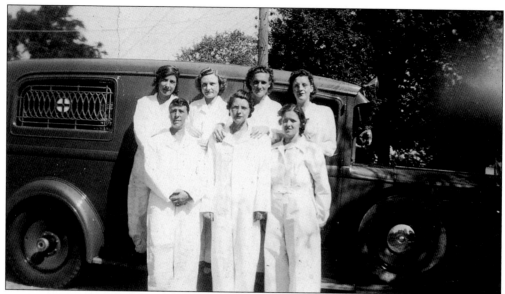

The Brick Township First Aid Squad was the first such emergency service to be organized in the town. The American Women's Voluntary Services, headed by Mrs. Alan Kissock, organized the Brick Township First Aid Squad in 1942. Their first ambulance was a 1931 Packard.

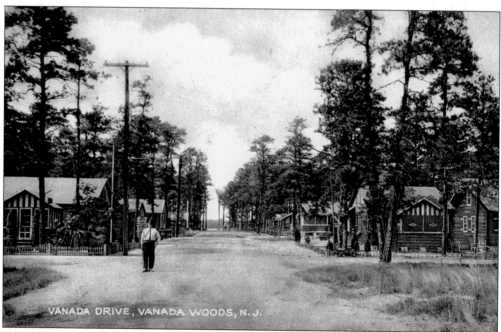

VANADA DRIVE, VANADA WOODS, N. J.

Prior to 1958, Brick Township had little need for a police force. Law enforcement was carried out by a constable and by the New Jersey State Police. A non-salaried, volunteer Special Police Force was organized in 1958 with John Rotundo as chief. The force's duties included traffic control, nightly patrols, and support activities at local schools. On July 17, 1972, a Brick Township Police Department was organized.

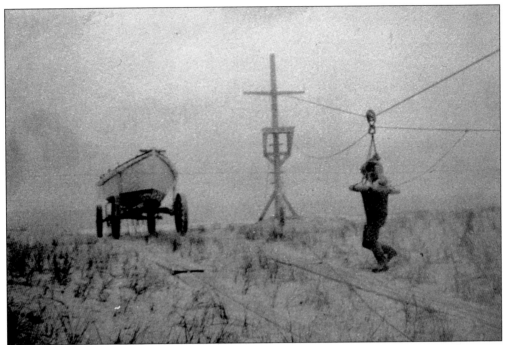

Because of their community's proximity to the Atlantic Ocean, Bricktonians played their part in life saving services. This 1913 photo shows a practice session in rigging a breeches buoy used to transport people to shore from ships that had run aground.

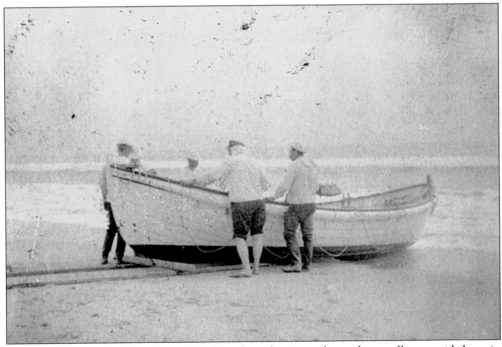

As long as there have been shipwrecks there have been people on shore willing to aid those in distress. In this 1913 photograph, a life saving crew is retrieving their life boat through the surf.

44

Three

LIVELIHOOD

The virgin woodlands of southern Monmouth County attracted settlers to the area to build lumber mills and a pinewood industry. Bog iron found in the local ponds and streams led to the iron industry. Land was cleared, and substance farms grew grains, berries, and vegetables. The ocean and rivers provided fish for the table as well as introduced another industry. Eventually, retail businesses also began to appear.

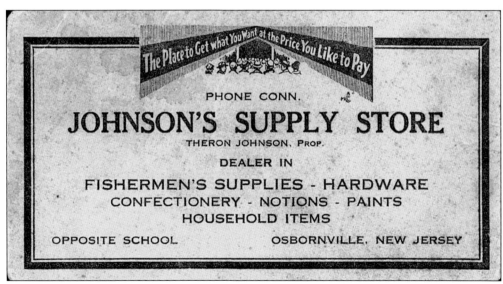

An advertisement for Johnson's Supply Store, Osbornville, New Jersey.

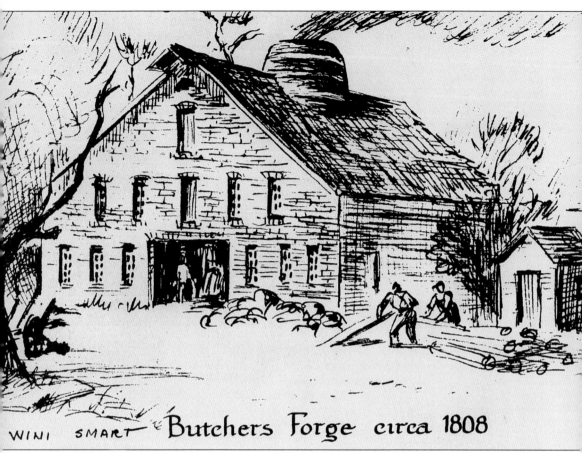

WINI SMART Butchers Forge circa 1808

The forge established by John Lippencott in 1808 became known as Butcher's Forge, then Burrs Forge for its later owners. The community around the forge became known as Burrsville after the Burr family, who later gained sole ownership of the forge. Using local and imported iron, the forge produced water pipes for New York City along with some utilitarian items. According to the New Jersey Gazetteer of 1838, the pond formed by damming the Metedeconk River was the largest millpond in the state. The village around the forge included a grist mill, a tavern, 2 stores, and 15 to 20 homes. All were lost in 1848 when the dam broke during heavy spring rains, washing away the forge and village.

Between 1824 and 1838, Nicholas Van Wickle operated his pottery factory along the south shore of the Manasquan River, along side the old wagon bridge (Osborn's Bridge). Van Wickle supplied the local population with gray and blue crocks, bowls, mugs, etc. In addition, Van Wickle served as a Monmouth County freeholder and a New Jersey assemblyman.

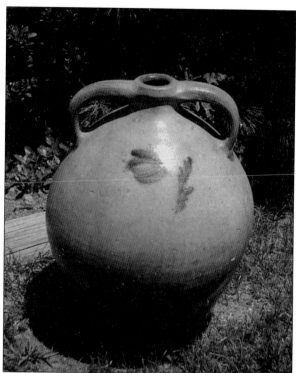

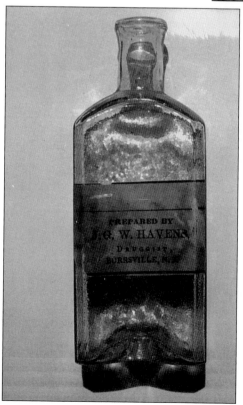

In addition to his civic duties, John Greenleaf Webb Havens was also a druggist. He and his brother ran Havens and Havens Store in Burrsville. Shown here is one of Havens's druggist bottles, c. 1860.

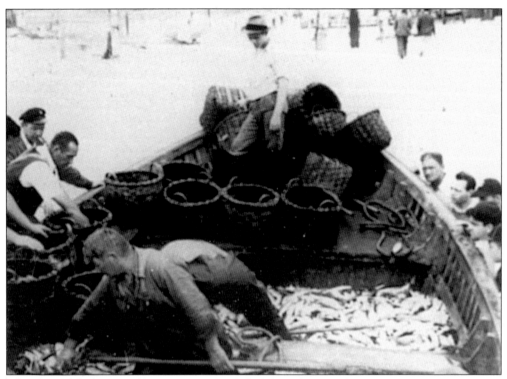

Once beached, the pound boats were unloaded of their day's catch.

FISHERMEN LANDING, MANTOLOKING, N.

Pound fishing took place from early spring to late fall. Fishermen would set their nets perpendicular to the shore and running out to sea where they would trap the catch. Here they can be seen landing their pound fishing boat on the beach.

48

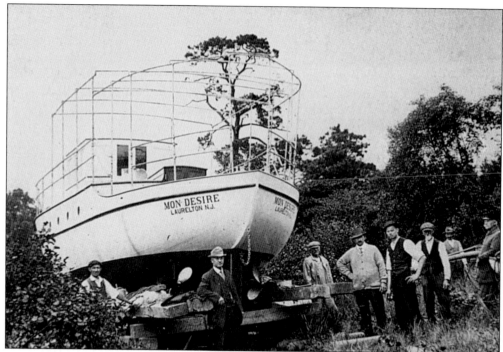

In 1878, when the village of Bay Head was still a section of Brick Township, Benjamin Hance established a shop to build small duck boats, rowboats, and sailboats. Though there had been boat builders all along the bay, this marked the beginning of boat building as an industry at the head of Barnegat Bay. This 1910 postcard shows the Mon Desire in dry dock

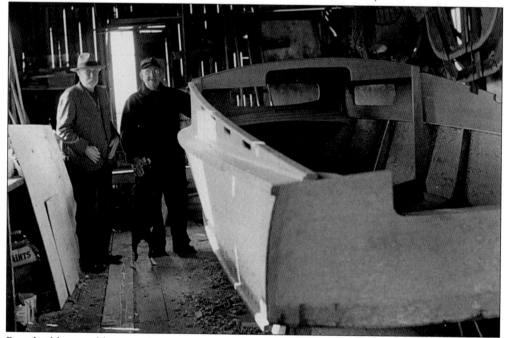

Boat building and boat yards were a seasonal business, but a few builders worked at it full time. This 1950 photograph shows Alger Brower, left, a longtime boat builder in Brick Township.

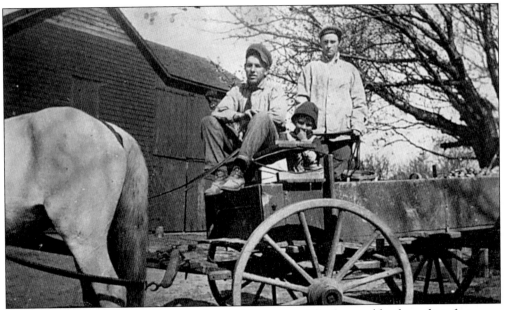

Floyd, Laura, and Joe Osborn are seen here with a wagon full of vegetables from their farm.

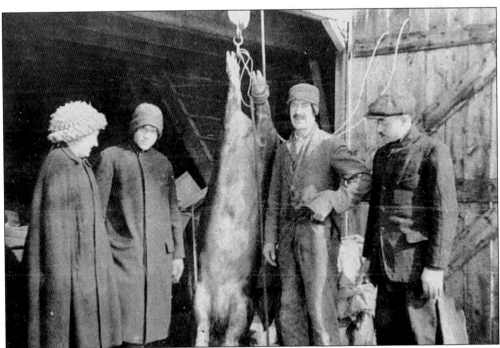

Most local people raised a pig to be slaughtered in the late fall when the weather was cold. Here we see the Kieser family about to butcher their pig. From left to right are George C. Kieser, Gustave J. Kieser, Richard E. Kieser, and an unidentified woman.

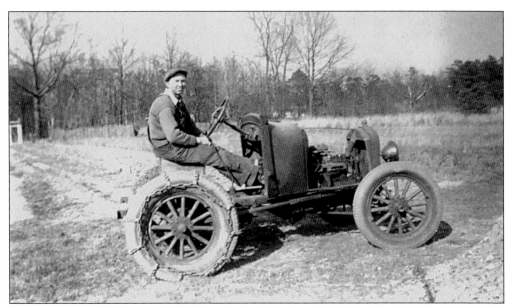

Harrison Osborn rides a makeshift tractor on his vegetable farm on Drum Point Road in Osbornville.

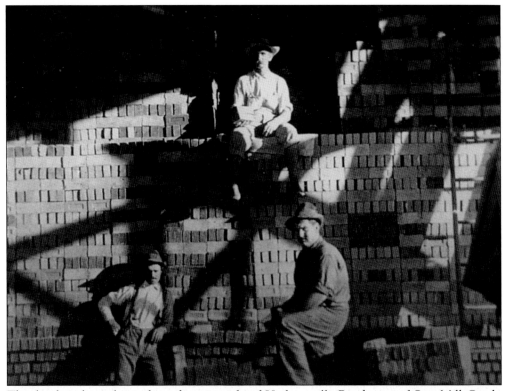

This brickyard was located on the west side of Herbertsville Road, east of Saw Mill Creek. The yard was operated by the Tilton and Hulse families and produced "slop brick" using clay harvested from nearby. The bricks were first air-dried and then placed in an oven to bake. One firing a year produced about 300,000 bricks.

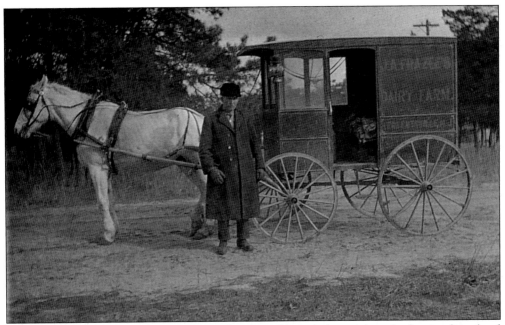

Pictured here is James Frazee with his milk wagon. Frazee's farm, where he kept a dairy herd and grew cowpeas, sorghum, and corn, was located on Herbertsville Road. The farm later became Bill's Dude Ranch. In the 1970s, it became the site of the Maple Leaf and Saw Mill Condominiums.

This 1910 postcard shows William Cook tending to his Crab Shack on Adamston Road in Osbornville. The sign on the shack identifies the sale of "Soft, Hard and Shedder Crabs."

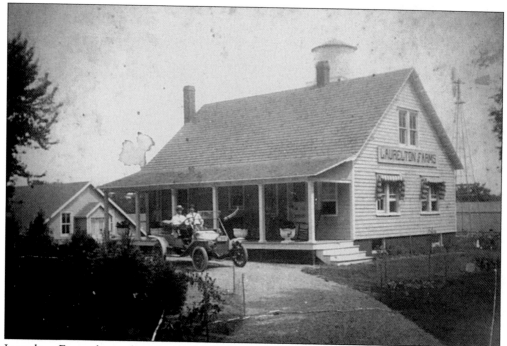

Laurelton Farms, located on the road to Lakewood (Route 88 West), was established in 1901 by Austin G. Brown and J.T. Sideman. In later years, the farm was owned by Riesser and Rothchild, who also established R & R Barbecue Chicken. The Roblenski family continued the business into the 1980s.

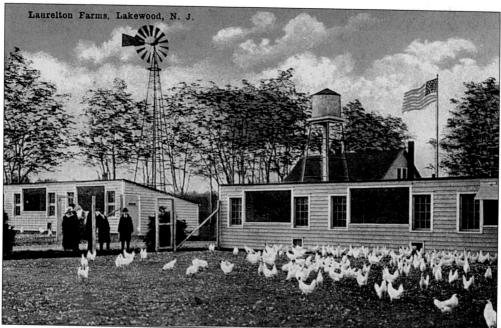

In 1909, Laurelton Farms was said to be the world's largest farm of single breed of 35,000 single-comb white leghorn chickens. The farm was sold in a sheriff's sale in 1930 to Samuel Kaufman who subdivided it into several smaller farms.

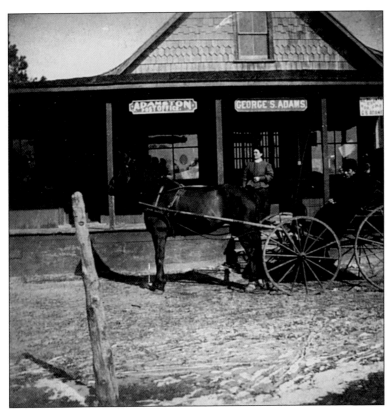

One of the very early stores to appear on Mantoloking Road was George Adams's store, seen here in an 1890s photograph. The store carried whatever the local population needed in the way of food supplies. The store also served as a post office.

Over the years, Brick Township has had a number of post offices and postal designations. The variety of designations has lead to some confusion over the name of the community. The postal cancellation stamp on the above postcard is from Adamston in 1910.

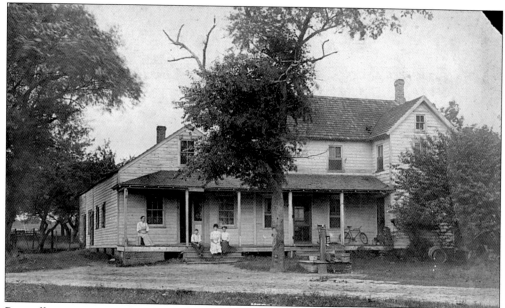

Post offices were moved from time to time. The Herbertsville Post Office was in the Tiltons' store, which was attached to their house. This building was located where the Herbertsville Firehouse now stands.

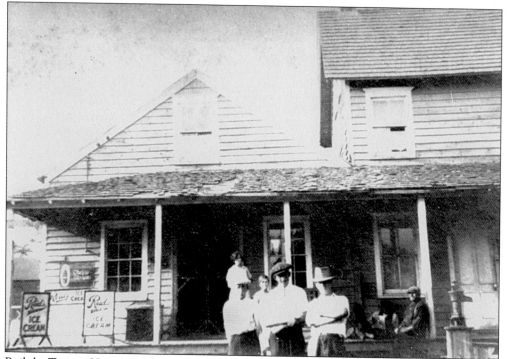

Built by Tommy Havens in the mid-1800s, this structure served as a home, a general store, and a post office. The store was located in what is today the parking lot of the Herbertsville Firehouse. Standing in front of the store are, from left to right, Marie Gant, Laura Sidney Havens, Ralph Hulse, Howard Hulse, and Everett Tilton.

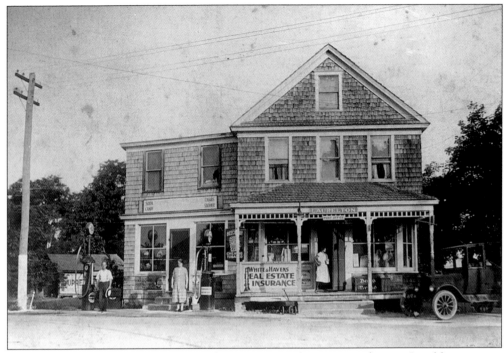

The White and Havens Store in Laurelton was more than a general store. It sold insurance, gasoline, groceries, chewing tobacco, and newspapers and also served as the local post office. The building was on the north side of Route 88 West, a short distance from Route 70.

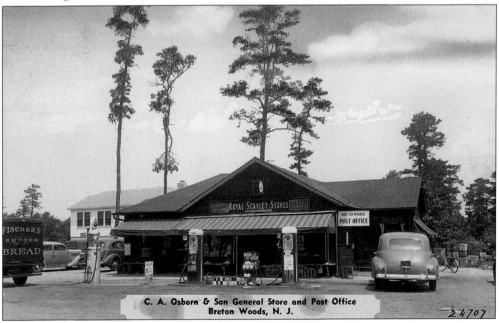

This 1940 photograph shows C.A. Osborn and Son Royal Scarlet Store on Adamston Road in Breton Woods. The store sold Honor Brand Frosted Foods as well as other items usually found in a grocery store, including newspapers, Abbotts ice cream, and Texaco gasoline at 21 cents a gallon. This store also served as a post office.

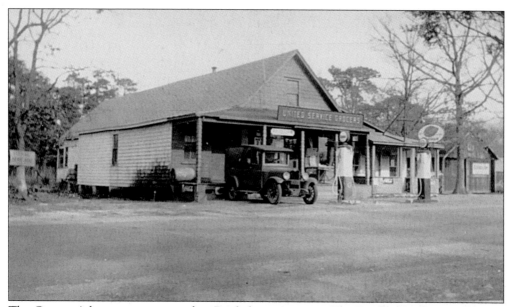

The George Adams store remained in Brick for many years. The Bonhag family ran the store when this 1920s photograph. As United Services Grocers, the store sold Breyers ice cream, Coca Cola, and Esso gasoline and was also the site of the post office for awhile. By 1999, the old store had been converted to an auto repair shop.

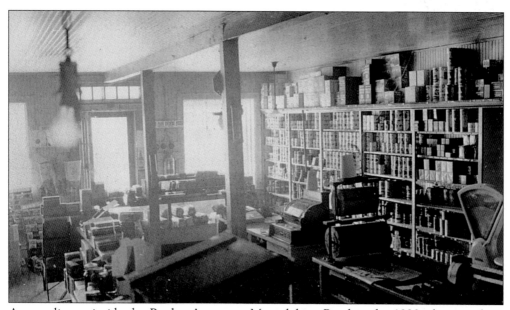

A rare glimpse inside the Bonhags' store on Mantoloking Road in the 1920s shows a plain, well-stocked store. A sign between the door and the window advertises the *Asbury Park Evening Press*.

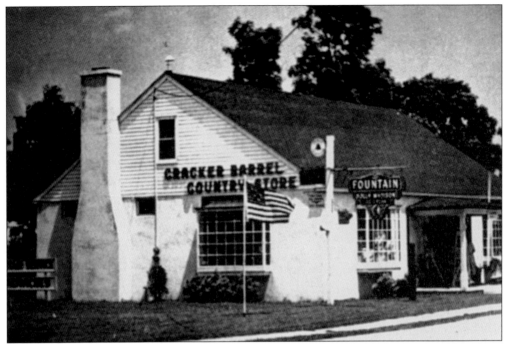

When the White and Havens Store and the Havens and Havens Store in Burrsville (Laurelton) were long gone, the Cracker Barrel, run by the Downey family, was opened on May 28, 1948 to fill the needs of the local population. The store was located on Princeton Avenue and served as a gathering place for the locals as well as a post office.

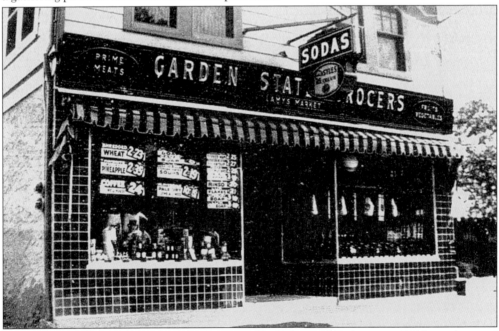

At Garden State Grocers on Hooper Avenue in the Cedarwood Park area in 1950, two boxes of shredded wheat sold for 23 cents, a pound of coffee for 24 cents, and two cans of concentrated soup for 19 cents.

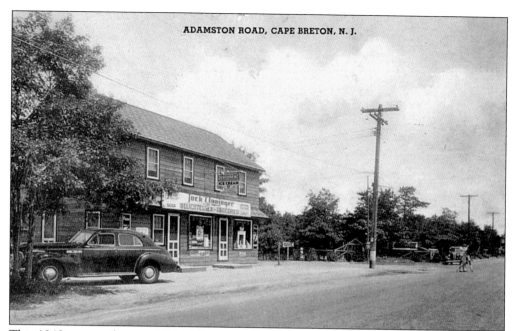

This 1940s postcard was published for Jack Cloninger of Cape Breton. Jack Cloninger's Deli and Grocery Store was located on the corner of Mantoloking Road (also known as Adamston Road) and Bretonian Drive.

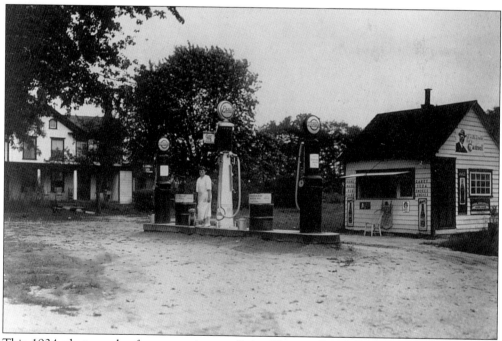

This 1934 photograph of a gas station on Point Pleasant Road (Route 88 East) shows the combination business carried out there. The station sold Esso standard gas for 20 cents per gallon and premium for 23 cents per gallon. A sign on the building advertises the sale of candy, smokes, lunches, and homemade pies. The sign above the window says "I'd walk a mile for a Camel."

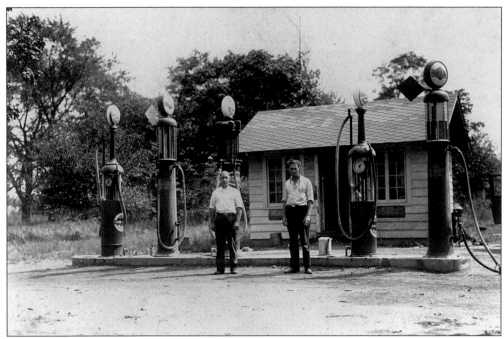

One of Brick's earliest gas stations was started by Walter Havens on the Point Pleasant Road. Walter and his son-in-law Ray Durrua continued to operate the station through the opening of the Laurelton Circle in 1937. Ray's son Walter operated it through the construction of the Laurelton interchange and into the 1990s. Today, the Jersey Paddler is in the same location.

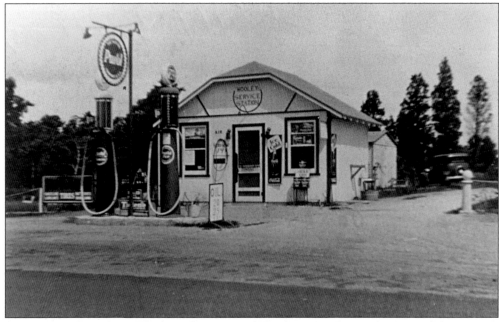

At 22 years of age, Tom Wooley, the owner of Wooley's Gas Station on Mantoloking Road, served as the postmaster at the branch post office inside his station. Wooley was one of the organizers and volunteers of the Community First Aid Squad. Tom's wife, Helen, took over the gas station and post office duties when Tom went out on calls.

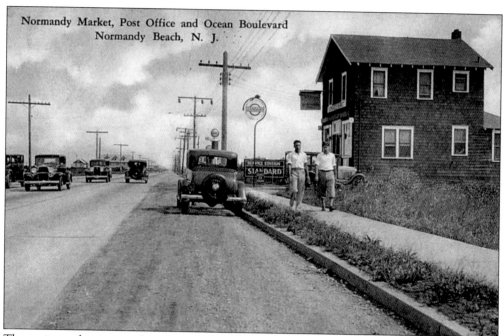

Normandy Market, Post Office and Ocean Boulevard
Normandy Beach, N. J.

The main road going north and south through Normandy Beach was constructed in 1913 and was later designated Route 37 and, then, Route 35.

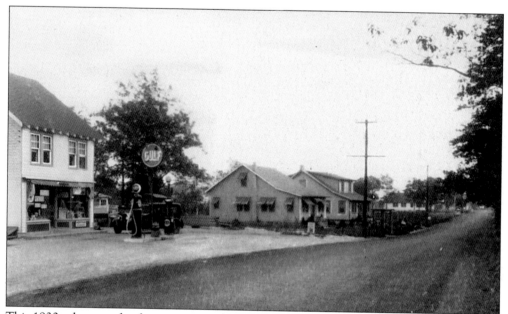

This 1930s photograph of a grocery store/gas station shows Hooper Avenue and the store that would later become Garden State Grocers.

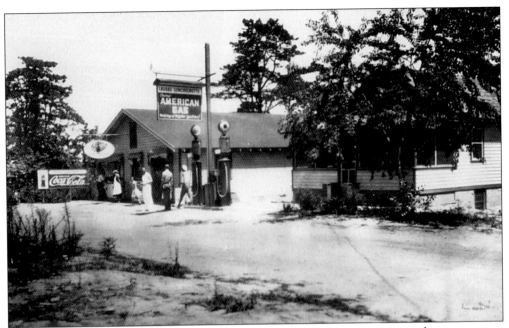

In addition to selling gasoline, Laura's Luncheonette had a walk-up service window.

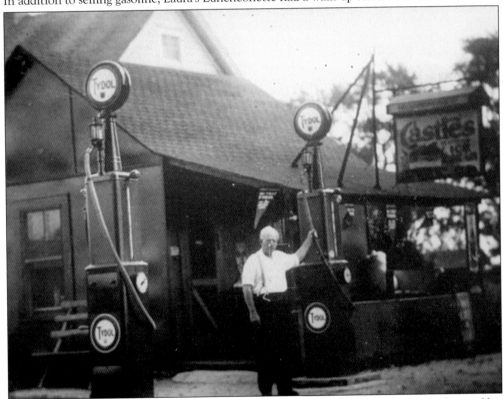

Carl Madsen moved to Brick Township in the 1920s and opened a gas station in front of his home on Route 88 West. Carl also had a confectionery store there where he sold penny candy, ice cream, and newspapers.

Joseph Wert built and ran the first gas station on Herbertsville Road. The station in the Riviera Beach area had just been upgraded when the postcard was made in 1940.

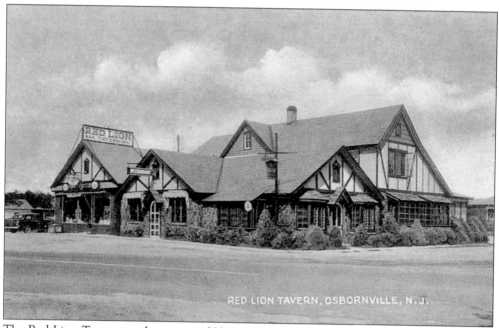

RED LION TAVERN, OSBORNVILLE, N. J.

The Red Lion Tavern on the corner of Hooper Avenue and Drum Point Road was built and run by Joseph and Phyllis McClorry until 1957. The tavern was advertised as a bar and grill, and meals were served in the restaurant. In 1958, the establishment became Citta's Red Lion Tavern and was one of the few places to buy a pizza in Brick.

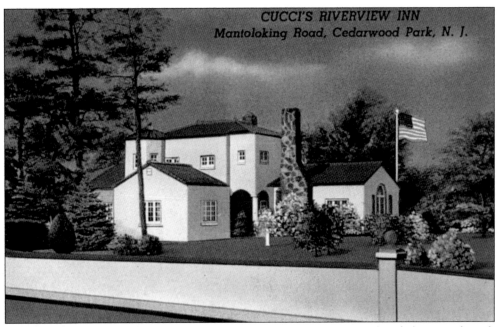

CUCCI'S RIVERVIEW INN
Mantoloking Road, Cedarwood Park, N. J.

This postcard advertised Cucci's Riverview Inn on Mantoloking Road and the Metedeconk River. The postcard gave directions to the restaurant from Jersey City and New York City. The inn served beer, wine, liquor, and excellent cuisine according to the postcard.

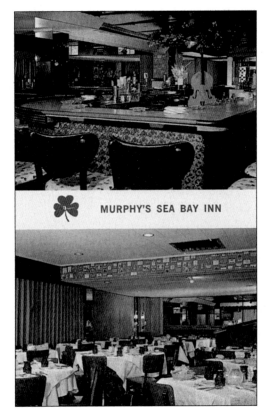

MURPHY'S SEA BAY INN

Murphy's Sea Bay Inn in the Normandy Beach area was advertised in the 1950s as "the liveliest spot on the Jersey Coast. Fabulous food, continuous entertainment, wall to wall people." Patrons also got to sing along with "Murph" (Harold Murphy, proprietor).

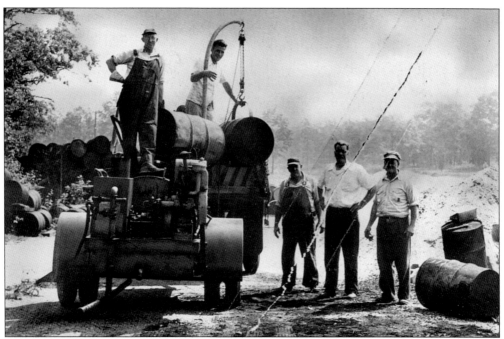

There was a time when the sand roads of Brick were coated with oil to keep the dust down. Here we see an Ocean County road crew preparing the oil-spreading equipment. The man standing on the truck with gloves is foreman William Osborne of the Osbornville section of Brick. Osborne served on the Brick Township Committee for 12 years.

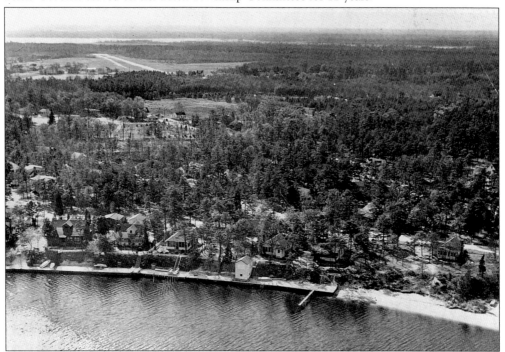

This is a 1950 aerial view from the Metedeconk River looking south over Kingfisher Cove in the foreground. In the background can be seen Ocean County Airport and Kettle Creek.

Ocean County Airport, also known as Osbornville Airport, was established by Bruce Huppert, a World War II flyer, and was in operation from 1946 to 1958. A commercial flight course was given by instructor Emil Repas. In April 1948, William A. Hiering made the first solo night flight at the airport. There were 14 planes of various types docked there. Huppert would later serve on the Brick Township Committee, and Hiering would later become a state senator. The airport land was sold to U.S. Homes after 1958, and the Sky Manor development was built there.

Four

HOMES

The early Brick Township homes were in the vernacular farmhouse style, constructed in the post-and-beam tradition and joined together with mortise and tenons. Over the years, these homes were expanded upon to meet the needs of growing families, but the area was in an architectural time lag. The Georgian style of the early 1700s didn't arrive in Brick until the early 1800s. A housing boom began to appear in the early 1900s as Brick began to develop as a resort community. A second building boom, which brought in even more permanent housing developments, began with the opening of the Garden State Parkway in the 1950s.

The Wagner House, built c. 1780.

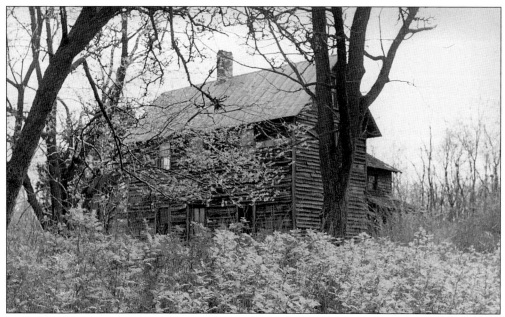

This 1959 photograph shows a house that once stood proudly on the corner of Van Zile and Burnt Tavern Roads. This farmhouse shows its unpainted and weathered cedar clapboards, a single chimney, and a tin roof, which is unusual for this area.

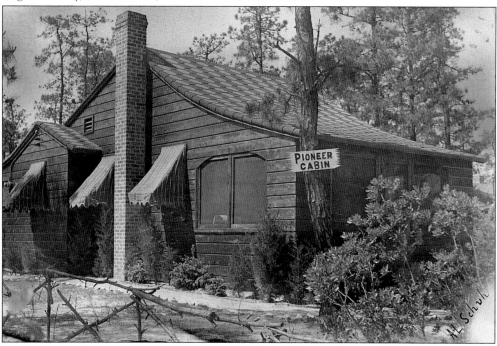

Pioneer Cabin was one of five building styles offered by Van Ness Corporation in 1934 at their Breton Woods development. Model homes ranged from eight-room styles to the Pioneer Cabin, a one-room model, which was advertised as a "distinctive rustic design." Prices ran from $685 for the pioneer model to $985 for a complete model that included water, a septic system, and a 40-by-100-foot plot.

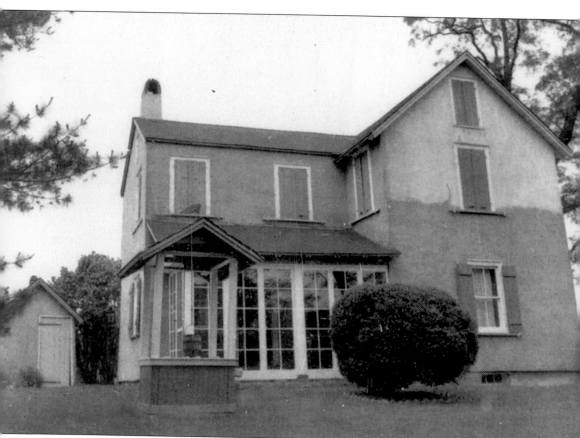

The Herbert-Colvin House, pictured here c. 1838, was built by Hampton Herbert, one of five brothers who settled in the Herbertsville area. The building remained in the Herbert family until 1921. In 1924, Charles and Clara Colvin purchased the vacant building and 60 acres of land on which Charles built an airstrip for his plane. He owned Pioneer Aviation Instrument Company, which he later sold to the Bendix Corporation. Pioneer Aviation Company designed the compass used by Charles Lindburgh on his first solo flight across the Atlantic Ocean in 1927 in the Spirit of St. Louis. The farmhouse and land are now a part of the Manasquan Wildlife Reserve.

In the 1930s, when this photograph was taken, the James Pettit House was in Laurelton on the Point Pleasant Road (Route 88 East).

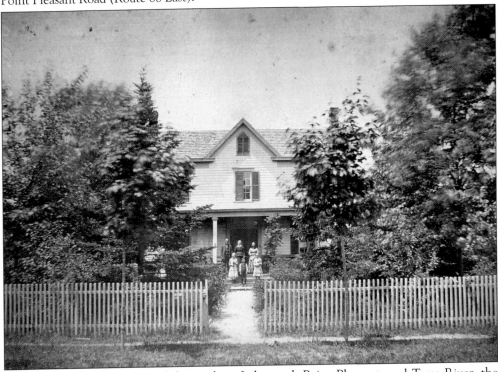

Located on the intersection of the roads to Lakewood, Point Pleasant, and Toms River, the Havens Homestead, seen here c. 1857, was donated to Brick Township for use as a library in the 1960s. The building was moved to make way for a shopping center and was eventually demolished. Pictured here in front of the house during better times are, from left to right, (front row) Lydia Tilton, Horatio Havens, and Mary Lydia Havens; (back row) H. Ely Havens, Emma Havens, and an unidentified person.

Pictured on the right is Captain Frank Robbins of the steamer Sandy Hook. Frank was the son of Captain Enoch Robbins, both men were from Burrsville.

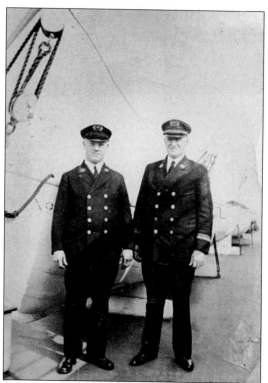

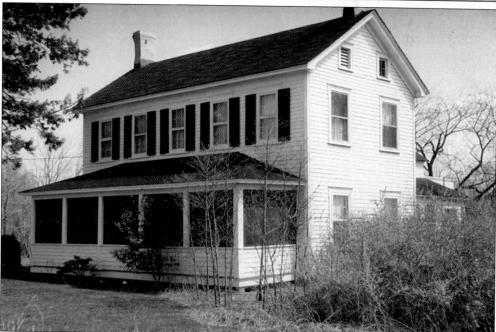

Pictured c. 1861, the Captain Enoch L. Robbins House on Route 88 East is the last remaining complete farmstead in Brick Township and includes a cow barn, a horse barn, a two-seat privy, and a tool shed. Captain Robbins sailed to many locations in the world and brought back exotic items with which to furnish his home.

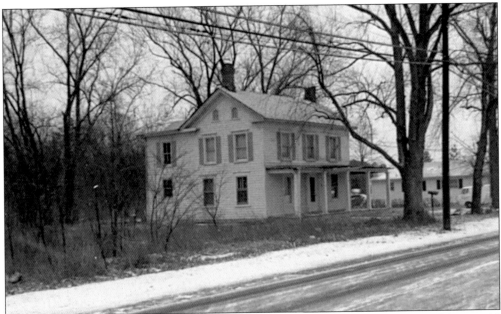

This c. 1830 Federal-style house was built for Jonathan Goble on Lakewood Road (Route 88 West) in Burrsville (Laurelton). The house is more commonly known as the Daisy House after a 20th-century owner. The building now houses offices and an apartment.

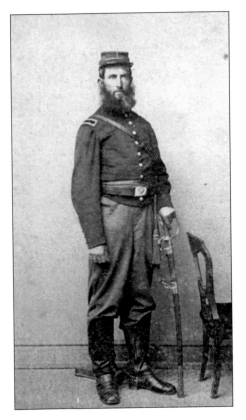

Pictured here is Captain Jonathan Goble in his military uniform. Captain Goble was a commission merchant with addresses in Burrsville and New York. Goble was also the captain of the First Battalion, Second Regiment of the Monmouth Brigade, a local militia, in 1848. Goble served as Brick Township's clerk in 1861 and as a New Jersey assemblyman in 1875 and 1876.

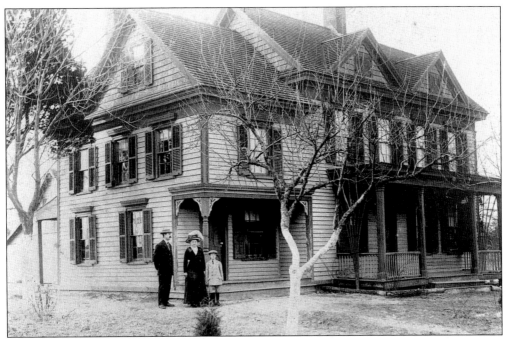

The members of the Gustave Kieser family are pictured in front of their c. 1861 home on Moore Road (Brick Boulevard) Standing, from left to right, are Gustave, Elsie, and Richard Kieser. Gustave held various positions in the local government.

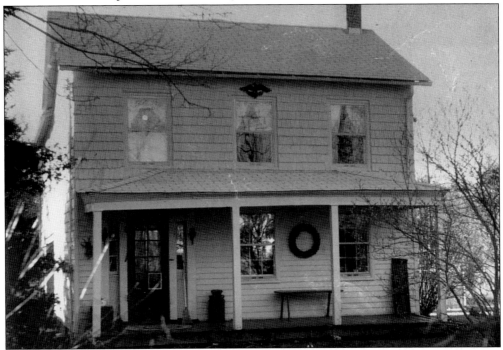

The c. 1810 Richard Burr House on Burrsville Road was the location of the First Township Committee meeting on March 12, 1850. The Burr family owned the iron forge at Forge Pond, and Richard Burr also operated an inn and tavern from his home during the 1850s.

During the 1940s and 1950s, the Minski family kept 200 pairs of mating minks on the ranch behind their home on Route 88 West. The ranch later became a horse farm and stable.

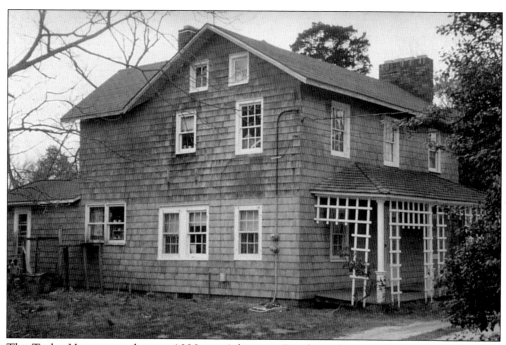

The Taylor House, seen here c. 1830, on Adamston Road was lost to a fire in the 1980s. The first floor had two rooms with oversized fireplaces that were added during the 1920s when the house served as a speakeasy. Gladys Taylor, a later owner, ran a well-known dog obedience school here.

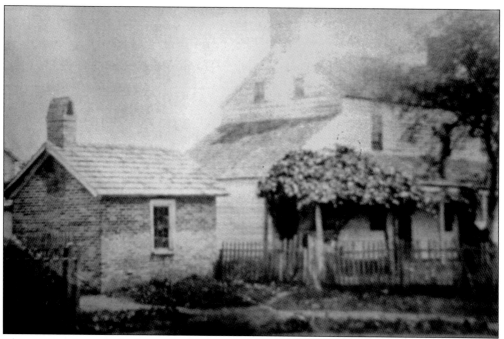

This 1880s photograph shows the Herbert-Osborn House on Herbertsville Road. The house was purchased in 1802 by Isaac Herbert, who owned the sawmill farther south on the road. The brick building in the foreground was a summer kitchen and smokehouse.

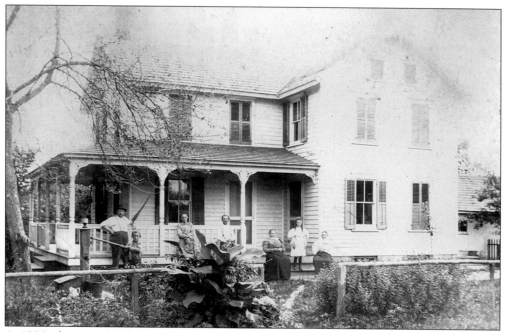

A 1900 photograph of the Herbert-Osborn House shows an addition perpendicular to the original structure with a porch, giving the house Victorian look. Pictured in front of their home, from left to right, are "Chicken" Joe Havens (with shotgun), Arthur Burdge (at water pump), Howard Havens, Ben Herbert, Addie Havens, Laura Havens, and Aunt Deb.

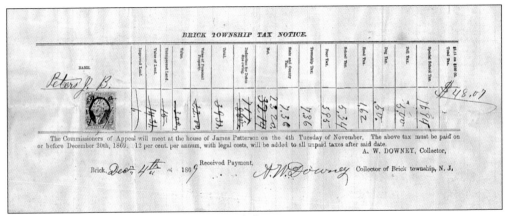

This is an 1869 Brick Township property tax bill.

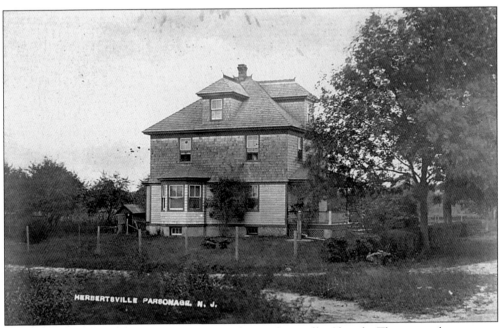

This 1900 postcard shows the parsonage of the Herbertsville Church. The original parsonage was destroyed by fire, and a second building was constructed using the original foundation and plans. Now a private home, the building stands on the northwest corner of Herbertsville and Lanes Mill Roads.

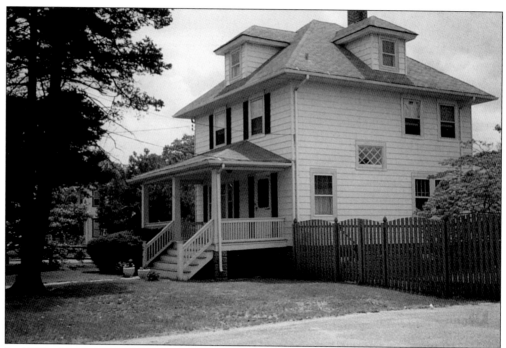

In 1871, there were 249 acres of land in cranberry cultivation in Brick Township, each acre worth $274. Pictured above is what became known as the "Cranberry House" on the corner of Drum Point and Cherry Quay Roads. This was the home of John and Mutah Van Note Patterson, major growers in the cranberry industry.

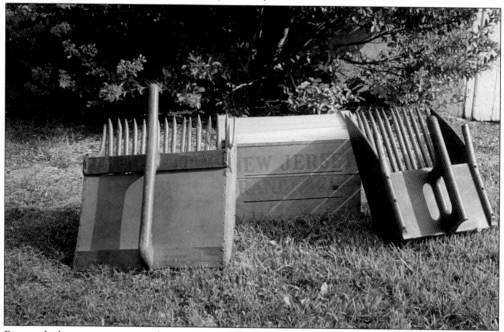

Pictured above are two cranberry scoops. The scoop on the left is wooden and has a slight upward curve to the metal teeth. The scoop on the right, also wooden, is slightly smaller and was popular in the Brick area. It is called a Cape Cod or Makepeace scoop.

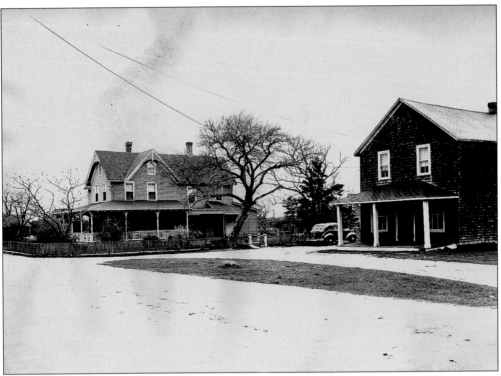

In 1949, Drum Point Road had on it houses of a variety of styles and uses. The large house in the background was a boarding house that rented furnished rooms and apartments on a weekly or monthly basis.

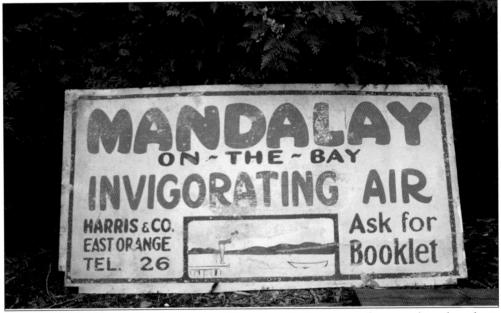

After the Point Pleasant Canal opened and introduced salt water to the upper bay, the salt air from Barnegat Bay was often used by developers to attract customers. On this sign, Harris and Company used "INVIGORATING AIR" to attract customers to Mandalay on the bay.

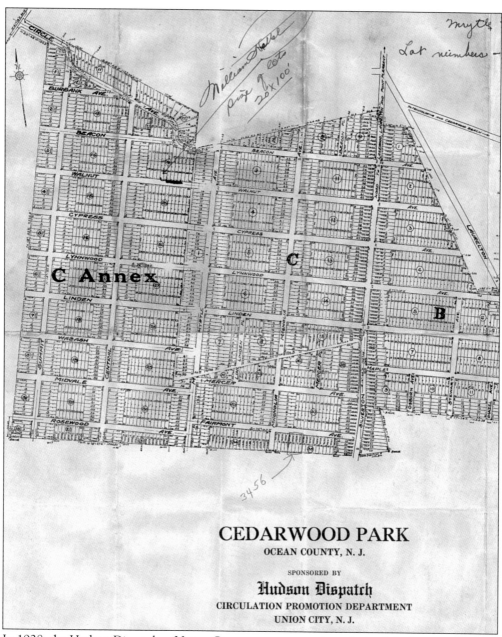

CEDARWOOD PARK
OCEAN COUNTY, N. J.

SPONSORED BY

Hudson Dispatch
CIRCULATION PROMOTION DEPARTMENT
UNION CITY, N. J.

In 1928, the Hudson Dispatch, a Union City newspaper, conducted a land deal promotion. The Hudson Dispatch created Cedarwood Park and subdivided the land into 20-by-100-foot lots. Each new subscriber received a lot. The catch was that one lot was not large enough to build on, so the subscriber would have to buy a second lot from the Dispatch.

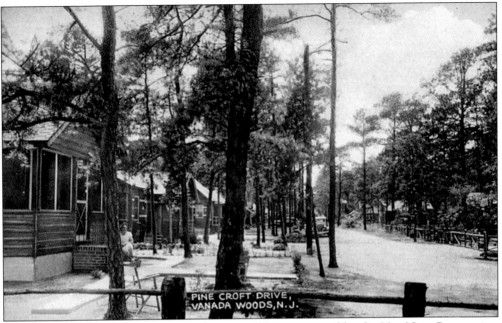

In order to keep housing costs down, the original houses erected by the Van Ness Corporation in 1939 at Vanada Woods were pre-cut by American Houses, Inc. In 1939, a house and lot sold for $895; by 1948, a house and lot sold for $2,195.

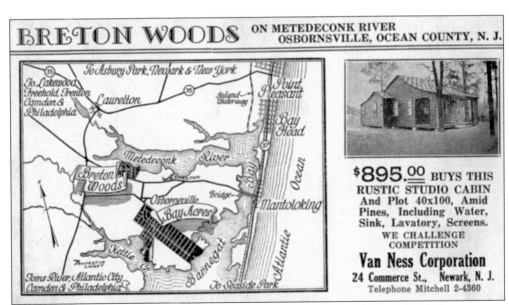

Until the end of World War II, many housing developments in Brick Township had restrictions on who could buy into them. The neighborhoods declared that they were a "Congenial American Community" or a "Gentile Colony - Desirably Restrictive." The complaints of war veterans slowly put a stop to this practice.

80

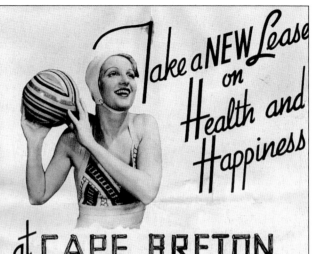
Advertisement for Cape Breton 1950.

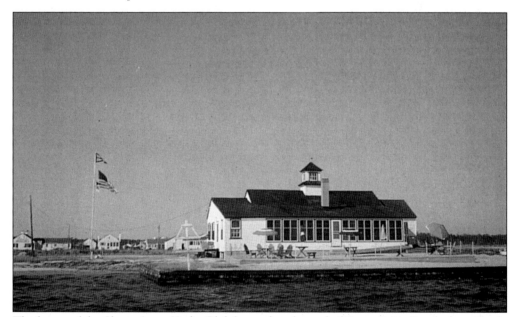

The home of the Shore Acres Yacht Club located at the end of Drum Point Road where Kettle Creek and Barnegat Bay meet. Dozens of sailboats can be seen here competing for honors on summer mornings.

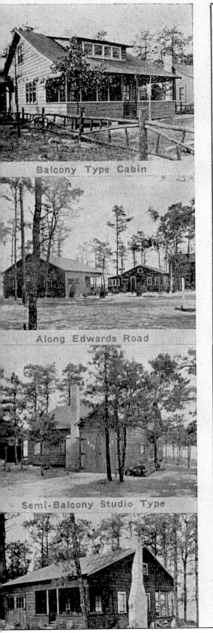

Balcony Type Cabin

Along Edwards Road

Semi-Balcony Studio Type

High Ab

Here is an advertisement for Breton Woods.

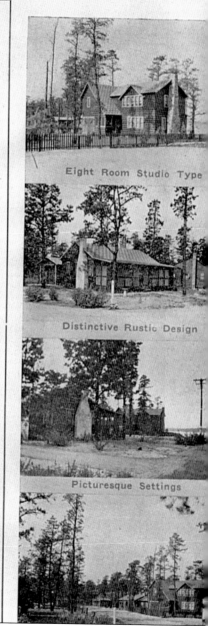

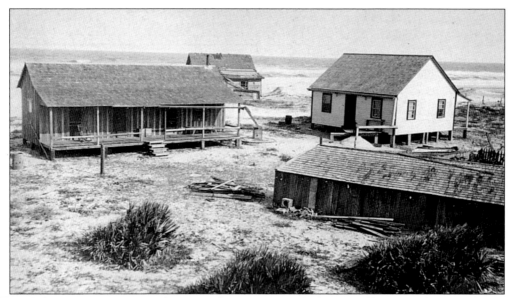

With the Atlantic Ocean on the east and Barnegat Bay on the west, the peninsula was occupied by a variety of fishing shacks and summer cottages.

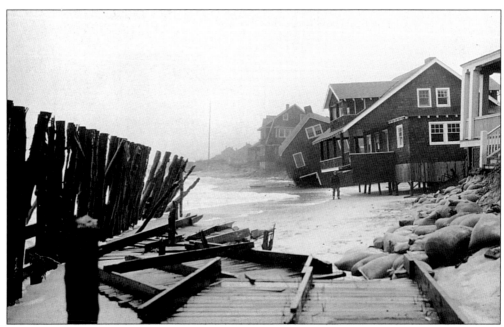

This April 1929 nor'easter was a disaster for the oceanfront homes on the peninsula area of Brick.

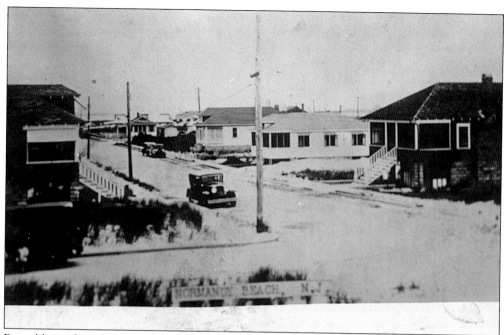

Raised bungalows line the unpaved streets of Normandy Beach as seen in this 1920s postcard. The road pictured here would later become New Jersey State Highway 35.

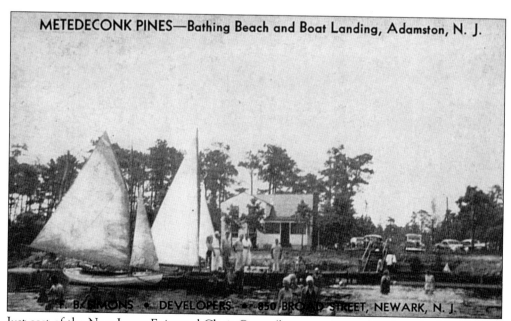

Just east of the New Jersey Episcopal Choir Camp (known as NEJECHO) on the Metedeconk River is Metedeconk Pines. This view from the water is from the developer's F.B. Simons advertising card.

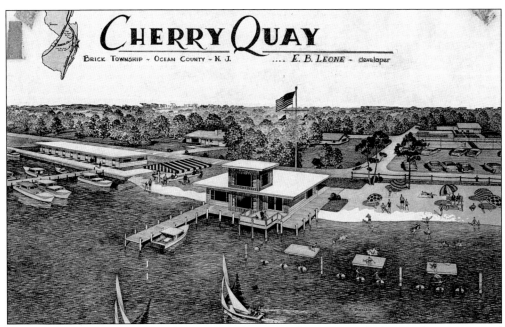

The original Cherry Quay development was begun in the 1930s and advertised as a restricted community. The advertisement stated, "There are no restrictions as to how much money is spent on a cottage or a cabin at Cherry Quay, but there is a restriction as to who spends it." These practices were ended when E.B. Leone took over as developer in the 1950s.

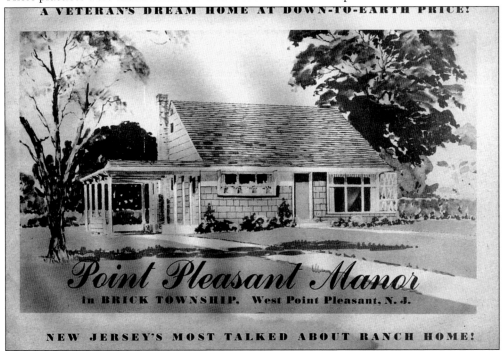

At Point Pleasant Manor on Harding Drive and Route 35 (Route 88 East) a house sold for $9,200 in the 1950s. Included in the price was a 72-by-100-foot lot, a car porch, three bedrooms, hardwood floors, and an expansion attic.

Five

RECREATION

Brick Township had all the natural advantages for its development into a resort area: the Atlantic Ocean, Barnegat Bay, and the Manasquan and Metedeconk Rivers. Resort developments began to appear in the early 1900s and reached a peak in the 1930s through the 1950s. These communities usually included a clubhouse and beaches. Slowly the resorts were converted to year-round homes, and the resort lifestyle slowly disappeared.

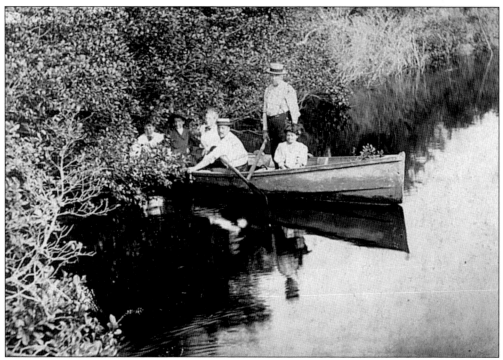

Boating on the upper Metedeconk River, c. 1890.

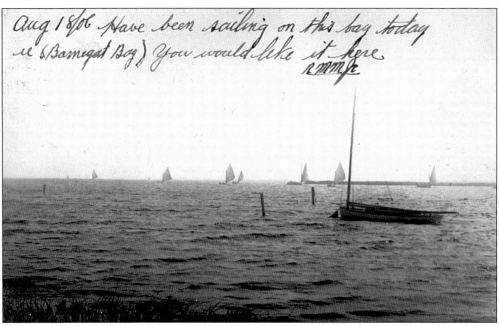

Aug 18/06 Have been sailing on this bay today re (Barnegat Bay) You would like it here n mm jr

This 1906 postcard view from the mainland of Brick looking across Barnegat Bay shows sailboats dominating the bay scene.

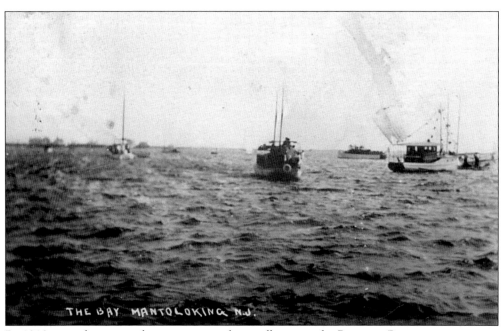

THE BAY MANTOLOKING N.J.

By 1910, powerboats were beginning to replace sailboats on the Barnegat Bay.

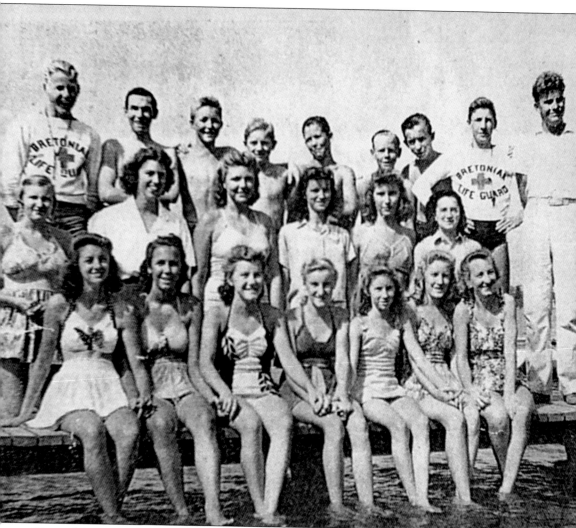

Pictured here are the members of the Junior Club of Cape Breton in 1941. They are, from left to right, (front row) Wilma Zirk, Jean Wabo, Edith Lanyi, Enid Eskdale, Peggy Sorge, Bernice Holmquest, and Violet Peever (advisor); (middle row) Edith Schweizer, Ruth Yater, Dorothy Wabo, Grace Payne, Betty Sorge, and Flora Chew; (back row) Jack Roberts, Joe Firms, Dick Mahoney, Richard Lanyi, Norman Wabo, Ted Kostler, Fred Kirms, Fred Eskdale, and Alvah Cook.

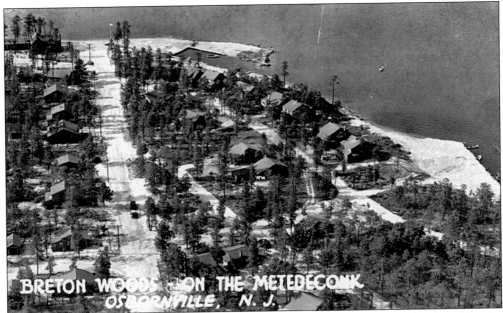

Breton Woods, located on the south shore of the Metedeconk River, was developed by the Van Ness Corporation in the 1930s. Howard Van Ness, the head of the concern, said that the construction of the new bridge to the area from Mantoloking, built in 1938, greatly aided sales. The selling price for a cabin and lot started at $685.

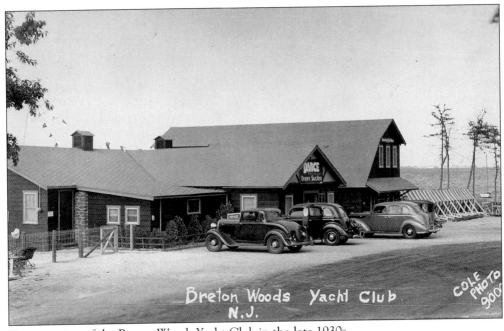

Here is a view of the Breton Woods Yacht Club in the late 1930s.

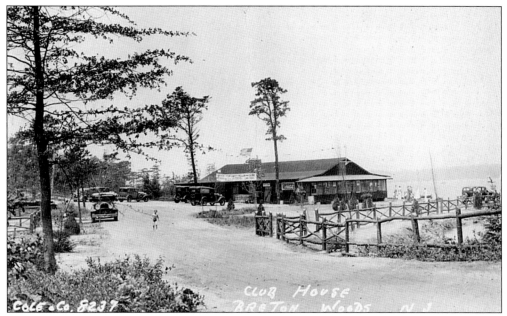

The Breton Woods development, including its clubhouse, in this 1936 postcard was once a part of Camp Burton, a Boy Scout camp. The 28 acres of Camp Burton were originally donated by Mathilda Steinam in 1924 in honor of her grandson Burton, who was killed in World War I. In 1930, the Boy Scouts of America, Monmouth Council sold the land to the Van Ness Corporation, which developed Breton Woods.

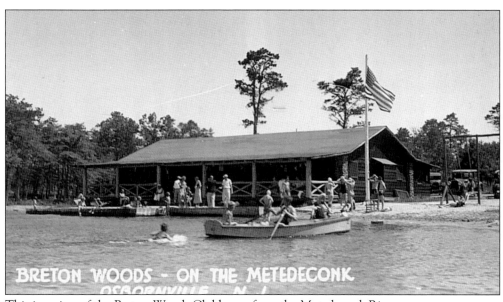

This is a view of the Breton Woods Clubhouse from the Metedeconk River.

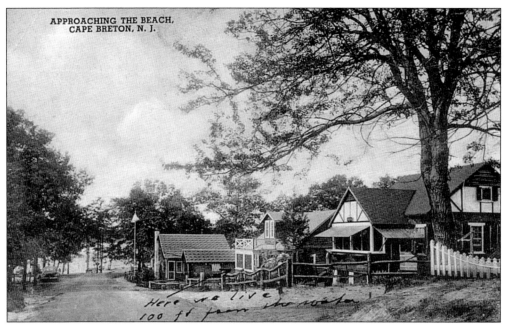

This is a view looking north towards the Metedeconk River on Bretonian Drive at Cape Breton.

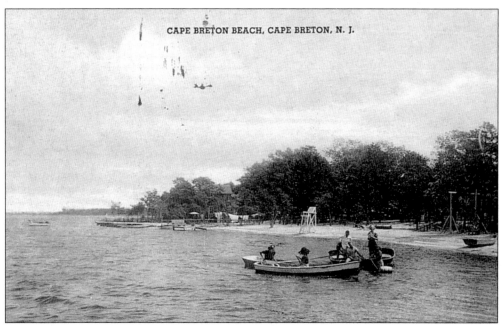

Each development along the water had a bathing beach, which the developer built to attract buyers. This 1943 postcard was published for Jack Cloninger's store on Mantoloking Road and Bretonian Drive.

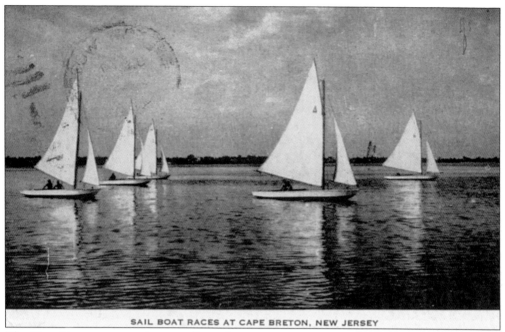

SAIL BOAT RACES AT CAPE BRETON, NEW JERSEY

The Cape Breton community, as well as other resort communities along the Metedeconk River, offered sailing lessons. Saturday morning was race time when sailors could demonstrate their skills. This postcard was made in 1952.

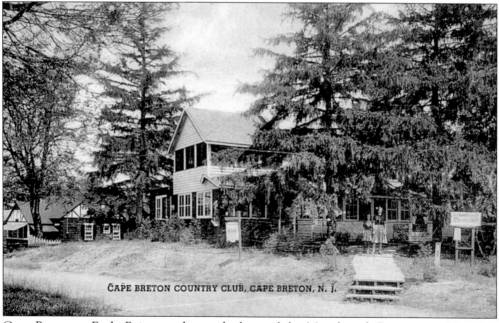

CAPE BRETON COUNTRY CLUB, CAPE BRETON, N. J.

Cape Breton at Eagle Point on the south shore of the Metedeconk River was a Van Ness Corporation development. Originally the site was home to a summer camp called Camp Eagle run by Joseph M. Child. The campers lived in screened pyramidal tents, and there was a pavilion by the riverbank. The camp's dining hall would later be used for the Cape Breton Clubhouse when the development was built in 1938.

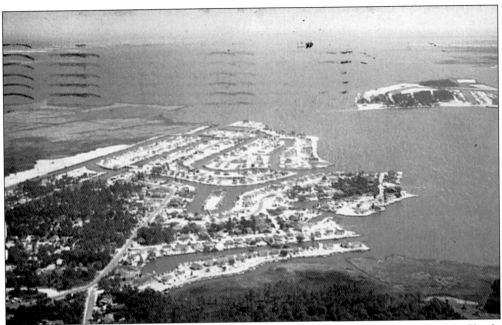

This aerial view of Shore Acres in the early 1950s shows the many lagoons leading to Kettle Creek and Barnegat Bay. From this photo we can see why the Vanard Corporation advertised Shore Acres as "the Venice of the Jersey Shore."

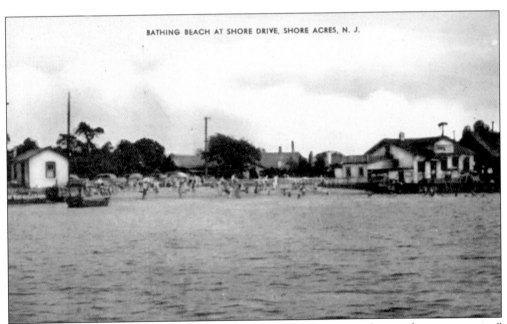

BATHING BEACH AT SHORE DRIVE, SHORE ACRES, N. J.

Bert Ward, the head of the Vanard Corporation, called Shore Acres a "boat at door community." Ward built a bathing beach and tennis courts in the community.

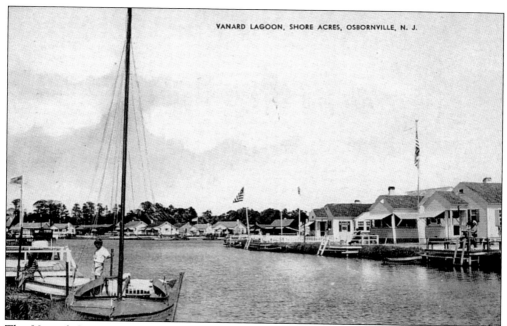

The Vanard Corporation started construction at Shore Acres in 1937. By 1938, ten homes had been constructed, and the remaining 34 lots were under contract to have homes built on them.

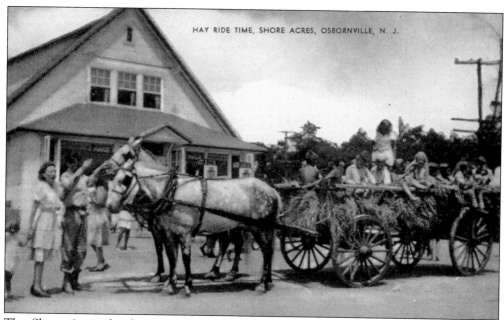

The Shore Acres development, with its many lagoons, was advertised in the 1930s as a "Homestead Special" and offered a bungalow and lot for $1,485 or $14.50 per month.

Summer activities always included a baby parade. At this parade in Breton Woods, Bonnie Schmidt Chankalian is in the white dress, fifth from the right. Can you identify anyone here?

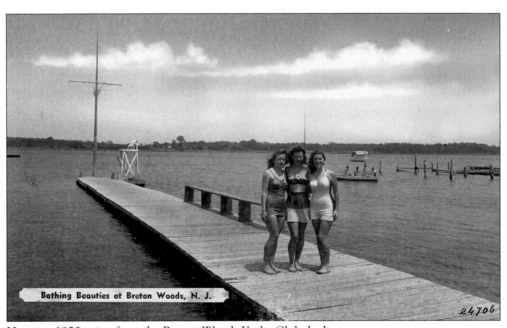

Bathing Beauties at Breton Woods, N. J.

24706

Here is a 1950s view from the Breton Woods Yacht Club dock.

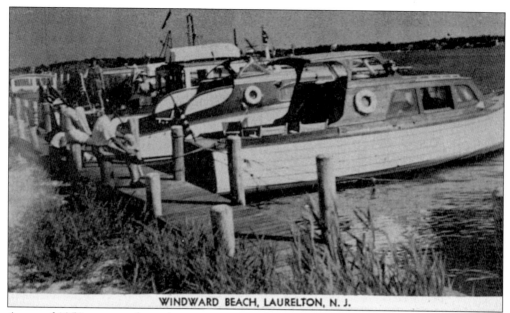

WINDWARD BEACH, LAURELTON, N. J.

A row of 1950s-era wooden cabin cruisers sit at the Windward Beach dock on the north shore of the Metedeconk River.

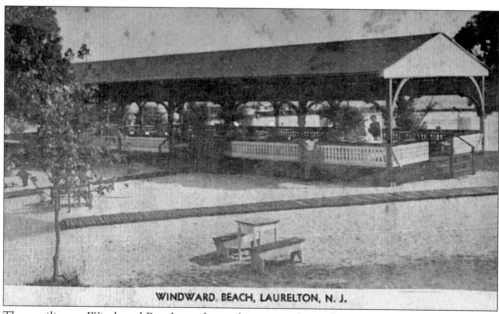

WINDWARD BEACH, LAURELTON, N. J.

The pavilion at Windward Beach was located on a rise above the river. It was the site for many activities, concerts, and dances and provided shelter when a sudden storm occurred.

The former Riviera Beach Clubhouse on the south shore of the Manasquan River was sold and became the Riviera Inn Restaurant.

Masquerade Dance
= AT =
Riviera Beach Club
Foot of Old Bridge, on Manasquan River,
Saturday Evening, Sept. 22, 1928
CASH PRIZES AWARDED
Music by RIVIERA CLUB ORCHESTRA
TICKET, Admitting Couple, 75c.
Come and Enjoy a Good Time

This flyer advertises a Saturday night dance at the Riviera Beach Clubhouse.

This is an advertisement for Chapman's Boat Sales in Riviera Beach, Brick, New Jersey.

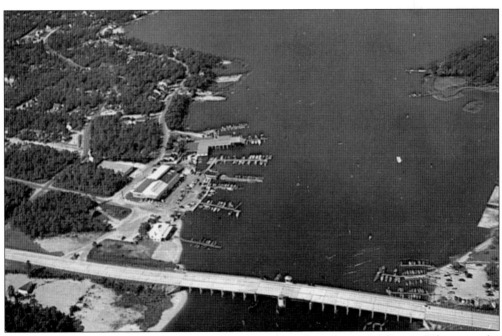

This aerial view of the upper Manasquan River Bridge, where Route 35 (Route 70) crosses the Manasquan River at Riviera Beach, shows the Riviera Inn and Chapman's Boat Basin.

Club House at Normandy Beach, N. J.

In 1916, the Normandy Beach Realty Company based in Camden, New Jersey purchased land for a proposed development on the beach area in Brick and Dover Townships. They promoted the area as a resort, and several other developers that followed continued the use of the name Normandy Beach.

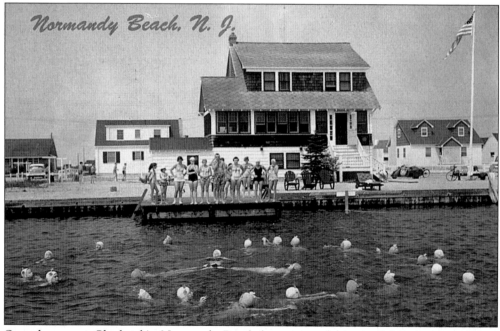

Normandy Beach, N. J.

Once known as Chadwick's, Normandy Beach began as a fishing and hunting community between the Atlantic Ocean and Barnegat Bay. It emerged as a sportsmen's center and later evolved into a resort community.

Chadwick's, which later became known as Normandy Beach, is the site of the oldest settlement along the beach area.

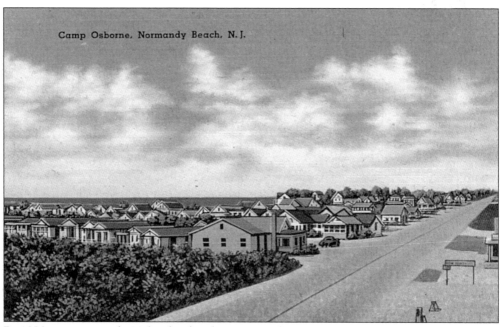

By 1929, approximately 20 families lived in Normandy Beach all year round. But camps, such as Camp Osborne, occupied the oceanfront land and made tourism an important industry.

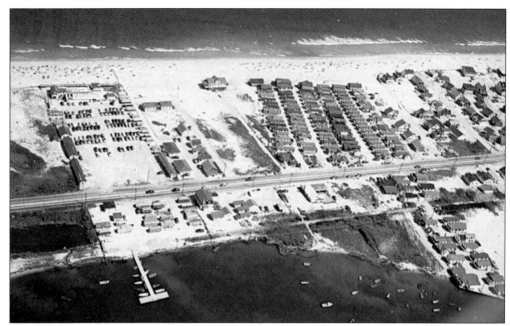

This aerial view of Camp Osborne and Sea Bay Park at Normandy Beach shows the width of the peninsula area between the Atlantic Ocean and Barnegat Bay.

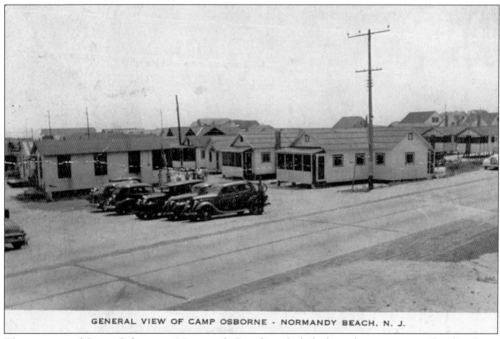

GENERAL VIEW OF CAMP OSBORNE - NORMANDY BEACH, N. J.

The cottages of Camp Osborne at Normandy Beach included a large living room with a fireplace, four to five bedrooms, an electric stove, and a refrigerator. This photo is from the 1930s.

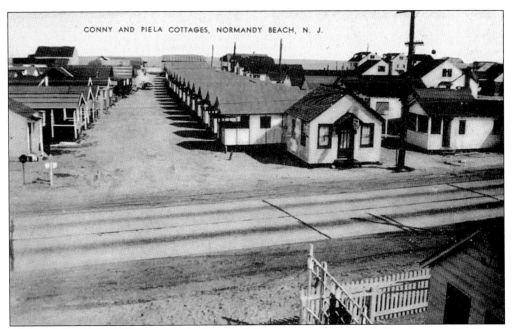

Along with Camp Osborne and Sea Bay Park Pavilions on Normandy Beach were the Conny and Piela Cottages, which could be rented on a weekly or monthly basis. The road in front of the cottages would eventually become Route 35.

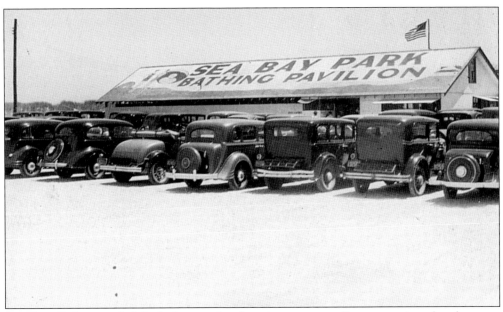

Sea Bay Park provided bath houses for day-trippers, as well as campsites for those on extended visits.

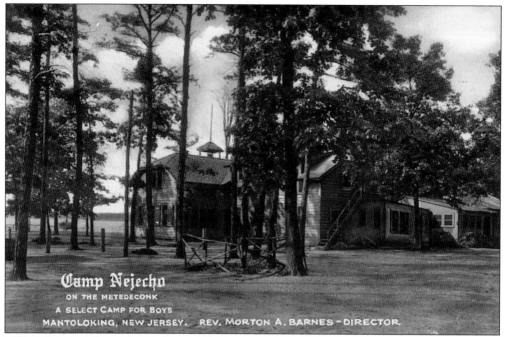

NEJECHO was located on the south shore of the Metedeconk River in the Adamston section of Brick. This summer camp was organized in 1907 by Reverends Elliot White and Martin Barnes.

The above postcard shows a NEJECHO dormitory, which was later converted to a private home.

Trinity Chapel was built at Princeton Basin, New Jersey on the Delaware-Raritan Canal in 1851. The chapel was moved to its present location at NEJECHO in 1934 where it served as a meeting/dining hall for the camp.

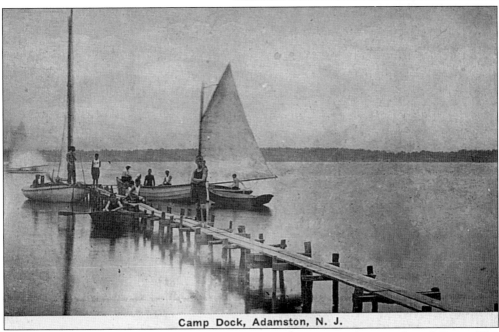

Camp Dock, Adamston, N. J.

The dock at NEJECHO was a narrow walkway jutting out into the Metedeconk River. The boats and buildings were maintained in the off-season by Charlie Maxon and his nephew Sam Morris, who lived across Mantoloking Road from the camp.

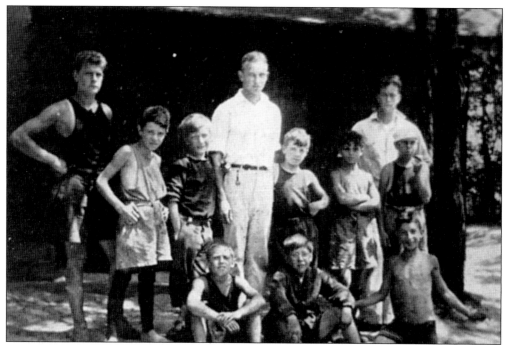

This 1920 photograph shows a squad from Princeton Summer Camp, which was located on the north shore of the Metedeconk River and Princeton Avenue. The boys attending the camp came from various city institutions such as the Big Brother Movement in New York City; the State Home for Boys in Jamesburg, New Jersey; and the Lighthouse Boys Club in Philadelphia.

One of many summer camps along the Metedeconk River, Princeton Summer Camp occupied 12 acres on the north shore of the river. Organized by graduates of Princeton University in 1909 and run by students of Princeton University, the camp served as a retreat for city boys. The camp was in operation until 1929 when the administrators felt the area was becoming too populated for a summer camp. Pictured here is the main building in 1920.

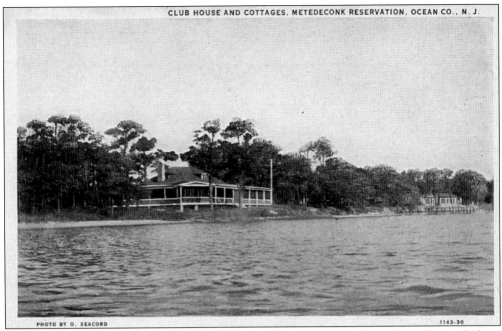

PHOTO BY O. SEACORD 1143-30

Organized as a summer camp in 1902, Metedeconk Reservation was located on the north shore of the Metedeconk River. The reservation was later sold for building lots and a marina.

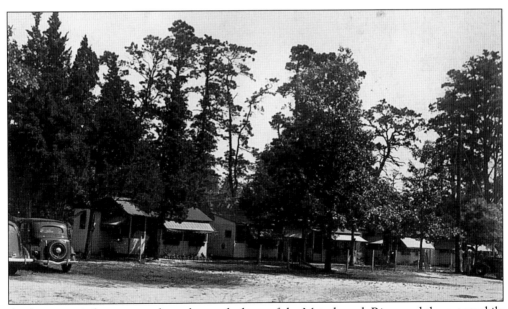

As the resort industry grew along the south shore of the Metedeconk River and the automobile made more areas accessible, tourism became an important industry. Here is Hulse's Landing in the Adamston section with its row of cabins waiting for vacationers.

107

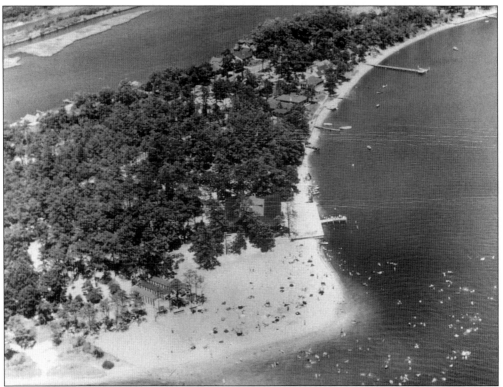

Theodore and Dalia Dickerson opened Metedeconk Bathing Beach Club on the north shore of the Metedeconk River in 1938. The club was operated into the 1970s when water pollution caused a decline in attendance. In this 1948 photograph, the clubhouse, the beach, and the bath houses can be seen.

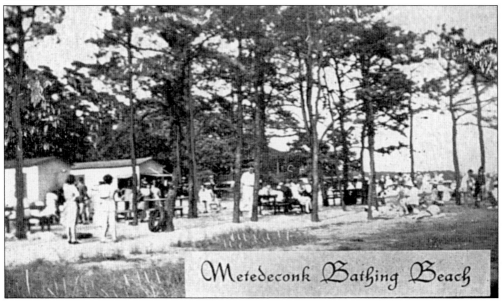

Metedeconk Bathing Beach Club had a clubhouse, two sets of bath houses, and a snack bar all uniformly painted yellow and brown.

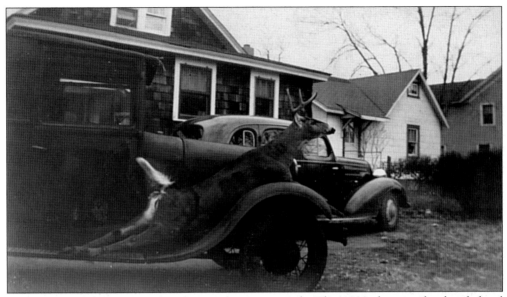

Hunting was both a sport and a necessity for many people. This 1930 photograph taken behind the Goble house on Route 88 East shows how this hunter proudly displayed his trophy on the fender of his car.

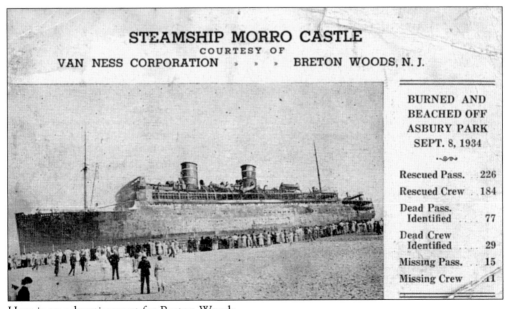

Here is an advertisement for Breton Woods.

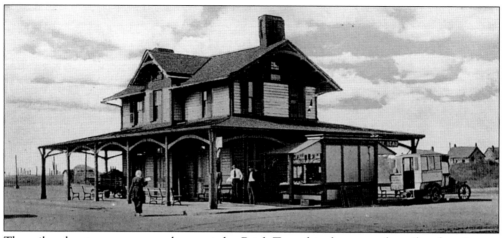

The railroad system never served present-day Brick Township; however, the railroad stations at Point Pleasant, Bay Head, and Mantoloking did serve the people here. Developers of the resorts along the Metedeconk advertised a free pick up at the rail stations for prospective buyers.

Bus companies made many attempts to run a bus service through Brick Township. In 1911, the Thompson Company ran year-round service between Lakewood and Point Pleasant. Later came the Chadwick and Graff Company, and in 1937, the Pillion and Shilba Bus Company of Lakewood ran the Lakewood-Asbury Park bus line through Brick.

Six

THEN AND NOW

The buildings, homes, and sites that are still here today help tell the history of Brick Township. Although changes have taken place during the past 150 years, these treasures remain to link the past with the present.

History is recreated at the 1827 Havens Homestead Museum. From left to right, Bob DiGrigoli, Kyleigh Sousa, and Karen Zitzow-Sousa welcome guests to an 1890's holiday tour in this 1998 photograph.

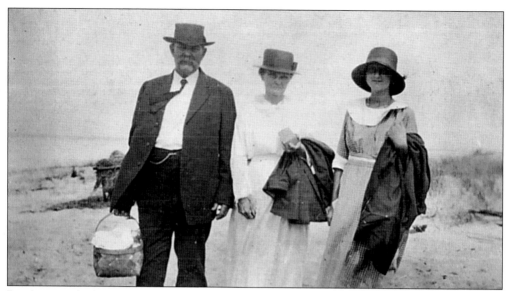

Big Sea Day had its origins in the traditions of the Lenape Indians, but white settlers would continue this tradition of gathering at the ocean for a weekend of entertainment and socializing. This photo is of Grandma and Grandpa Havens and cousin Vera Morton at Squan Beach on Big Sea Day.

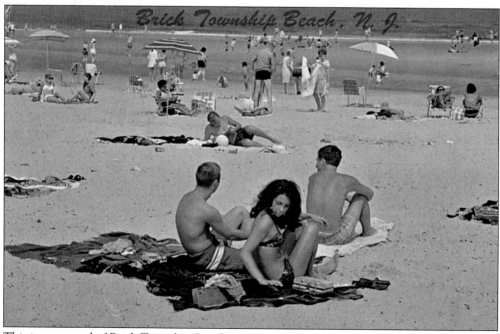

This is a postcard of Brick Township Beach in recent years.

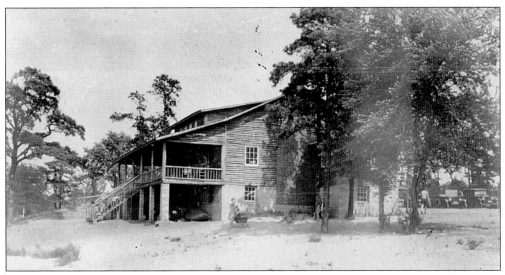

Though the Hudson Dispatch sold lots at Cedarwood Park on the Metedeconk River, a developer did build a clubhouse, as seen in this 1930s photograph.

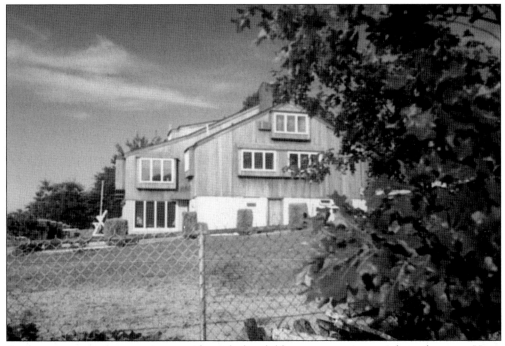

As the resort areas became more residential, the clubhouses were converted to other uses. Here, the Cedarwood Clubhouse was reconstructed as a private home.

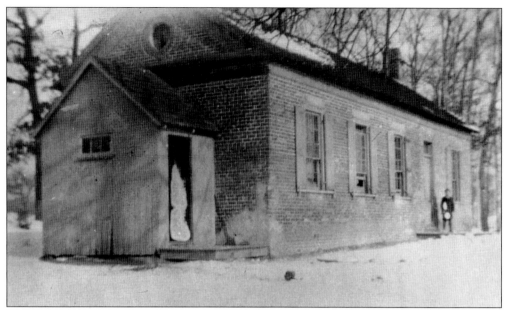

The original Herbertsville School was built in 1858 as a one-room schoolhouse on land donated by the Herbert family. A second room was added around 1910. The school was heated by a wood-burning stove, and in the 1920s, kerosene lamps were replaced by electricity. The school served the community until 1949 when a new four-room school was built on Lanes Mill Road.

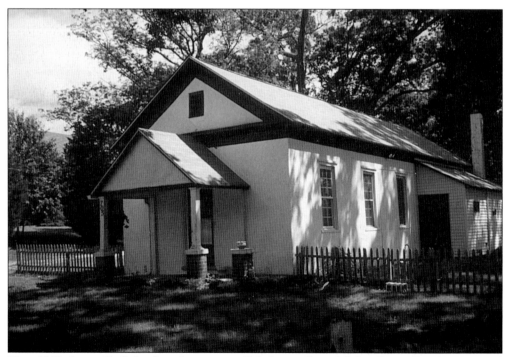

The old Herbertsville School on the corners of Herbertsville and Schoolhouse Roads is pictured here as it now looks as a private residence.

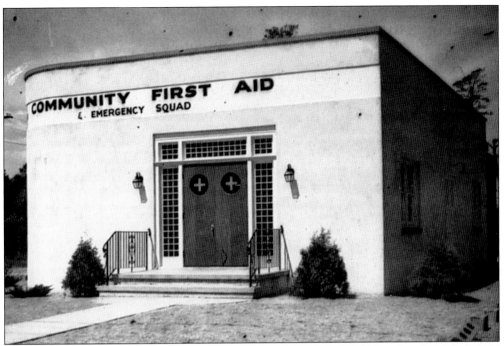

The Community First Aid Squad built a new headquarters on Mantoloking Road and dedicated the building on July 14, 1946.

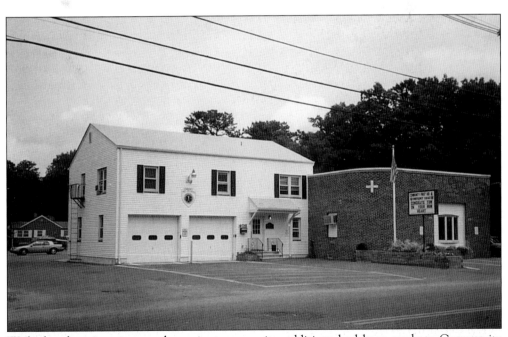

With the changing times and growing community, additions had been made to Community First Aid Squad's building by 1999. Also indicating the changing times is the marquee, which reads, "Congrats Tom on your new heart."

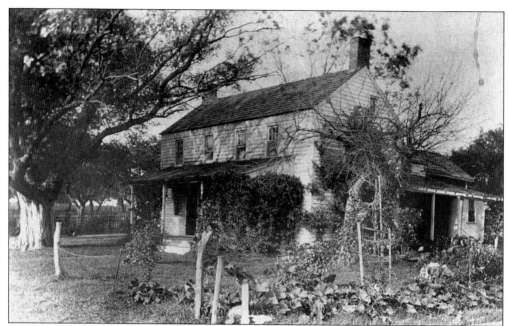

Purchased by Curtis Havens from Samuel Allen in 1827, the Havens Homestead on Herbertsville Road included a 15-by-14-foot cabin and 102 acres of land. In 1846, a five-room addition was constructed. The building was operated as an inn, providing bed and board to travelers. This photograph was taken c. 1910.

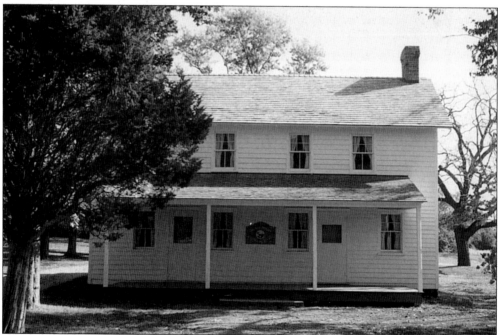

The Havens Homestead had been in the Havens family from 1827 until 1993. In 1993, Elmer and May Havens donated the building to the Brick Township Historical Society, Inc. The society restored and recreated an 1850s farmhouse and operates the house as a museum for the public to experience the lifestyle of early Brick inhabitants.

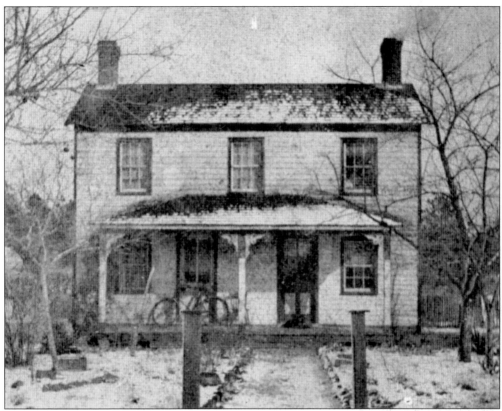

When the Civil War was over William H. Hall, who had served with Company E, 14th New Jersey Volunteers, returned home at the age of 25. In 1873, William and Rebecca Hall built their home on Adamston Road. This is an 1890s photograph of the Hall House.

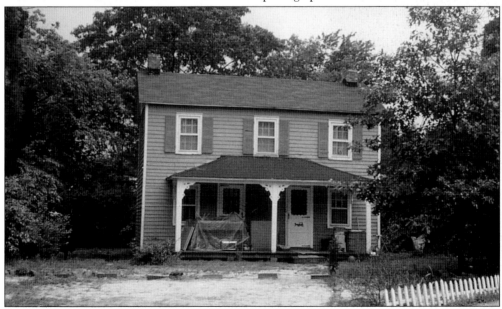

The William and Rebecca Hall House on Adamston Road is seen here in 1972.

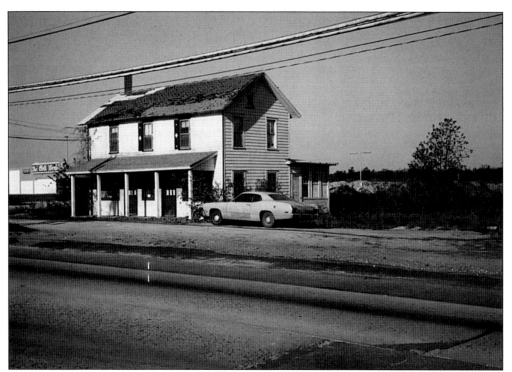

In the 1950s, the George P. Woolley House, c. 1875, was converted into two offices with the addition of two entrances and a change in the first floor windows as seen in this 1972 photograph.

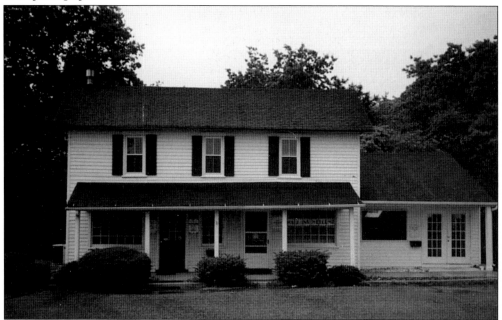

In the 1980s, Jack Martin Boulevard was constructed, linking Routes 70 and 88. The George P. Woolley House stood in the middle of where the boulevard was to be built, so the house was moved and now fronts on Jack Martin Boulevard.

Sidney Herbert's General Store on the east side of Herbertsville Road sold dry goods, provided mail order service, and served as a post office. Sidney also sold the services of his bull, "Red," to the local dairy farmers. It was common to hear politics discussed around the store as Sidney served on the Township Committee from 1882 to 1893.

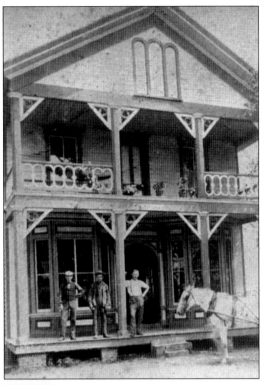

Sidney Herbert's building still stands on the east side of Herbertsville Road between Albermarle and Winding River Roads, and in the 1990s, it is a multi-family dwelling.

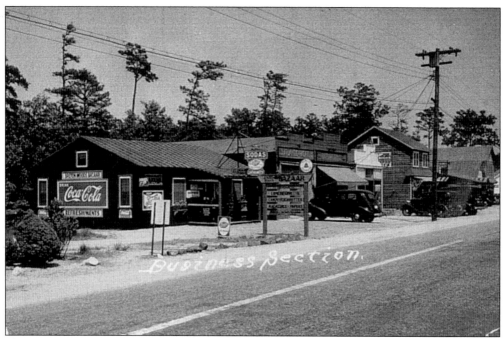

The business district of Breton Woods on the north side of Mantoloking Road, between Dock and Altier Roads, has seen little change in the 1930s, 1940s, 1950s, and 1990s. Looking from west to east (left to right) in this 1930s postcard, only the Bazaar/Luncheonette building is missing.

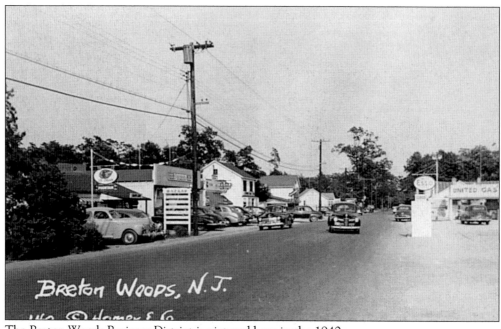

The Breton Woods Business District is pictured here in the 1940s.

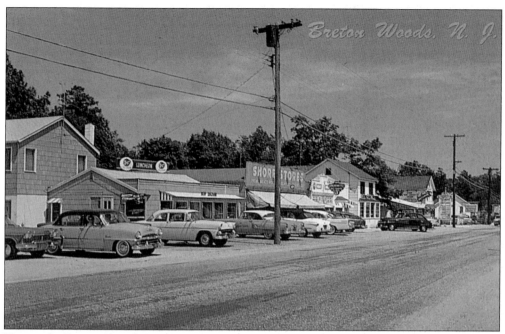

Here is the Breton Woods Business District in 1957.

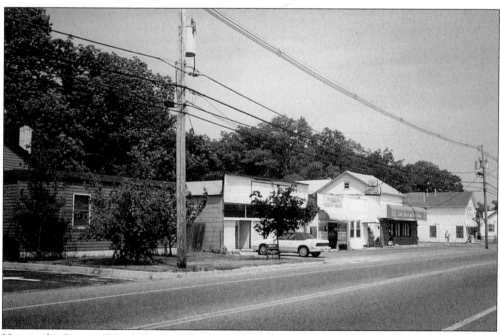

Here is the Breton Woods Business District again, this time in 1999.

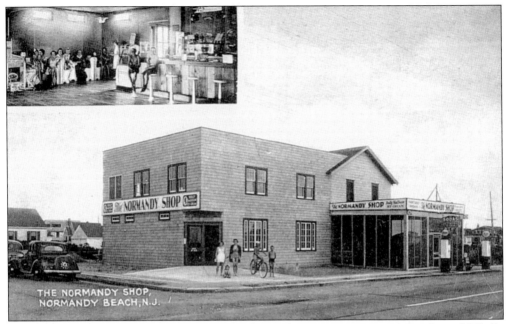

In the 1930s, the Normandy Shop at Normandy Beach was an ice cream parlor that sold Dolly Madison ice cream. One of the shop's features was a screen in the outside sitting area. The shop also sold Esso gasoline.

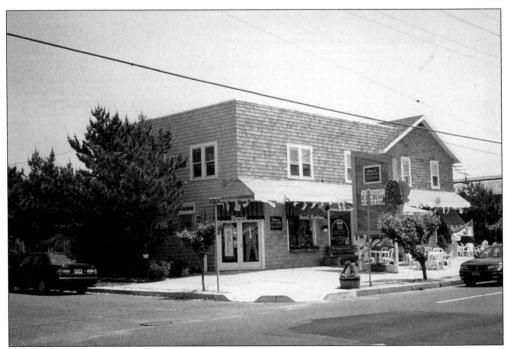

In 1999, the Normandy Shop at Normandy Beach became a clothing store, but a part of it is still an ice cream parlor with an outside seating area.

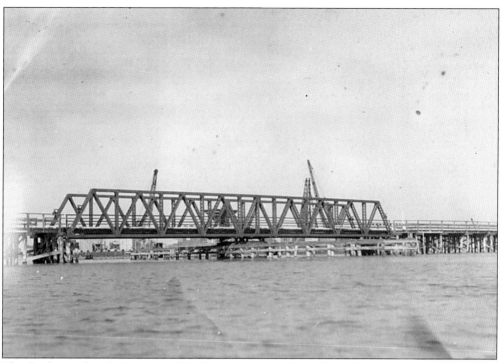

This bridge replaced the original bridge connecting Brick Township and Mantoloking. The power to operate this bridge was supplied by a four-cylinder gasoline engine. This turn-style bridge was taken down and replaced in the 1930s with a new bridge.

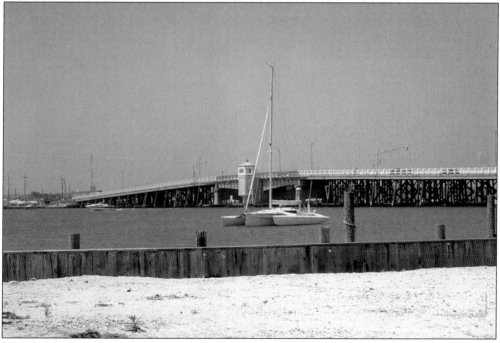

This drawbridge crossing Barnegat Bay from Brick Township to Mantoloking opened in 1938 and was the third bridge at this location. It was built as a WPA project.

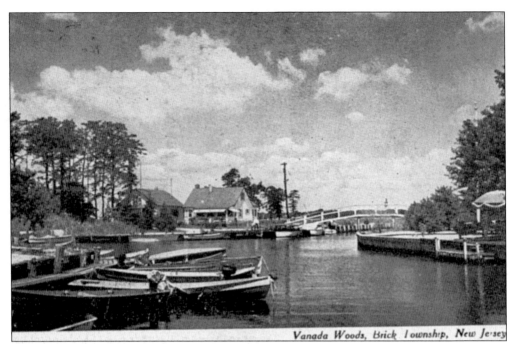

Vanada Woods, Brick Township, New Jersey

During the depression years of the 1930s, resort communities without access to waterways were slow to sell. The Van Ness Corporation at its Vanada Woods development overcame this by building a manmade harbor in 1939. This postcard gives a 1950s view of the harbor.

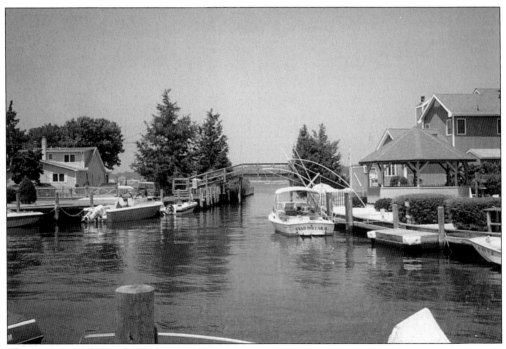

This is a view of Vanada Harbor in 1999.

124

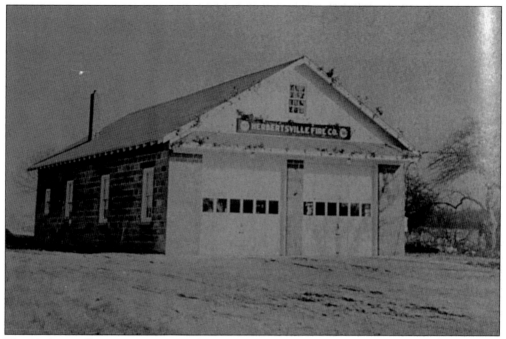

The Herbertsville Fire House is seen here shortly after it was constructed in 1940.

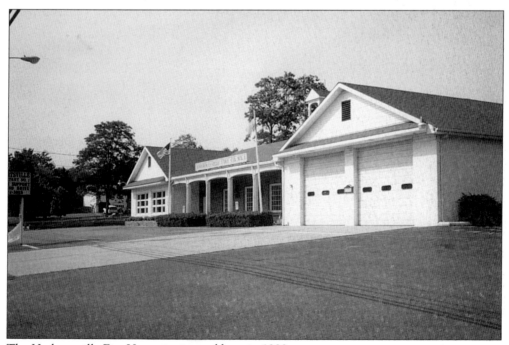

The Herbertsville Fire House is pictured here in 1999.

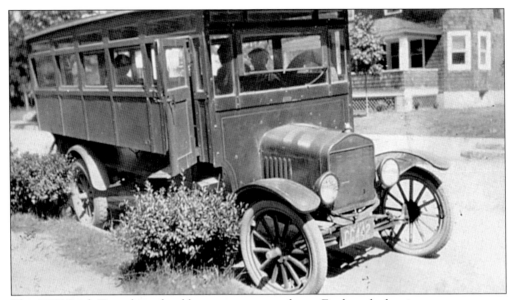

This 1927 Brick Township school bus was constructed on a Ford truck chassis.

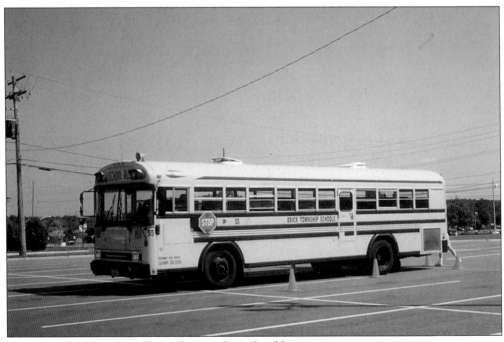

Here is the 1999 version of a Brick Township school bus.

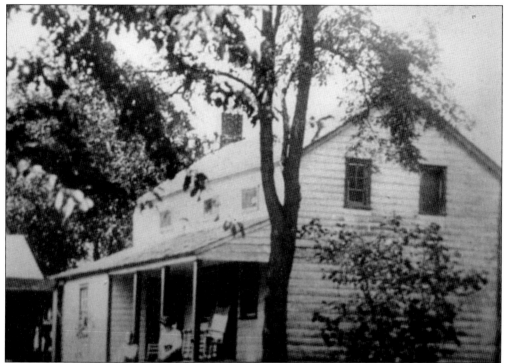

This 1909 photograph shows the house that Merrick Burdge Sr. purchased, along with 69 acres of land, prior to 1850. The house sits on a rise looking east down the Manasquan River.

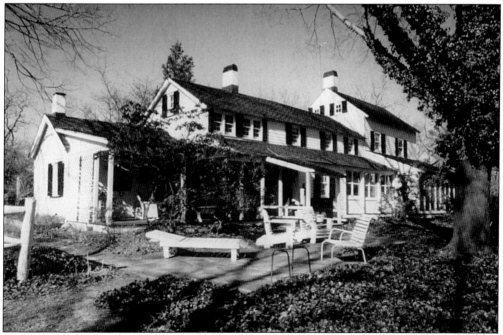

This 1990s photograph of the Merrick Burdge House shows the additions to the home since 1909. Each roofline represents a different era of construction; from left to right, they are the summer kitchen, the pre-1850 structure, and the post-1909 addition.

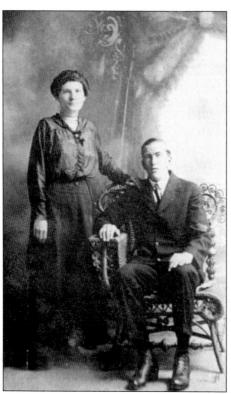

Percy Gant and his wife, Melinda Maxon Gant, were from the Osbornville section of Brick. Percy was a well-known decoy carver of the early 1900s.

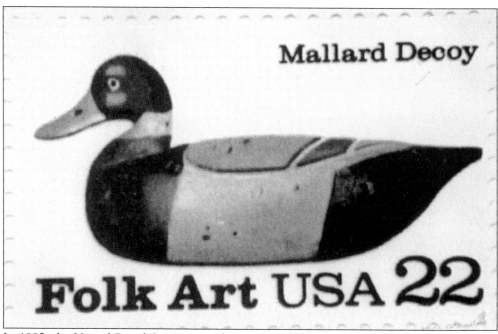

Mallard Decoy

Folk Art USA 22

In 1985, the United Postal Service issued a series of folk art stamps. Included was a mallard decoy carved by Percy Gant of the Osbornville section of Brick. Gant did his carving before 1964 and is included in a list of 63 major decoy carvers between 1850 and 1950. The original decoy that appears on the stamp is in the Shelburne Museum in Vermont.